100+ EASY *Calligraphy* PROJECTS

Shows how to put calligraphy to effective
use in a wide range of practical purposes
and gives inspiration for experimentation
in solving calligraphic problems.

By the same author

First Models in Cardboard
Make it from Paper
Paper for Play
The Zebra Book of Papercraft

100+
EASY
Calligraphy
PROJECTS

Creative ideas for putting basic calligraphy to practical use

G. ROLAND SMITH

Thorsons

An Imprint of HarperCollins*Publishers*

Thorsons
An Imprint of GraftonBooks
A Division of HarperCollins*Publisher*s
77–85 Fulham Palace Road
Hammersmith, London W6 8JB

Published by Thorsons 1989
7 9 10 8 6

© G. Roland Smith 1989

G. Roland Smith asserts the moral right to
be identified as the author of this work

A CIP catalogue record for this book
is available from the British Library

ISBN 0-7225-1852-8

Typeset by Harper Phototypesetters Limited,
Northampton, England
Printed in Great Britain

CONTENTS

INTRODUCTION

This book is intended for those who have already acquired some basic calligraphic skills and may be wondering what to do next. It therefore does not set out to demonstrate the formation of individual scripts, although several basic pen-written alphabets are included for easy reference.

The uses to which calligraphy may be put are many and various, as the newly accomplished scribe will soon discover when it becomes known that he or she can do a bit of 'beautiful writing'. The examples gathered here show how calligraphy may be applied in everyday situations. The pieces are mostly very short, and nearly all could be completed easily at 'one sitting'.

The embellishment or illumination of initial letters presents all sorts of difficulties for those who say they can't draw. If someone can produce a fluent and articulate script it doesn't automatically follow that they can also paint. The scribe and the limner were often separate people and many a fine document is the result of teamwork, the combination of several specialist skills. There are, however, many ways of producing ornamental or decorative letters without becoming too entangled with pictorial problems. These techniques form a large part of the book.

Although it can, of course, be used as a 'copy book' this is not the main aim. The idea has rather been to bring together some of the simpler methods and reasons for producing pen letters and drawn letters so that you can apply them with imagination to whatever assignment you may have in hand. I have suggested different approaches in the hope that you will use them experimentally. The ability to sustain rhythm and momentum throughout a lengthy inscription, and at the same time to remember how to spell, is something that comes only with practice. Even then mistakes will sometimes occur, but they need not inevitably spell disaster. Many valuable manuscripts show signs of having been corrected here and there. Most papers of good quality will stand careful scraping with a scalpel, and a tolerably good surface can often be restored by covering the area with tracing paper and burnishing with a smooth handle of a spoon or some similar implement.

It may be true that 'a bad craftsman blames his tools', but even the most accomplished calligrapher can scarcely be expected to succeed without suitable materials. Always try out the ink and the paper before embarking on a finished piece, especially a long one: there is nothing more annoying than to spend hours ruling up and marking out an inscription only to find that when you put pen to paper it behaves like cheap newsprint.

I find that a good strong water colour such as Designer's Gouache usually works well enough on Fabriano or Ingres paper, but the choice is vast. The enterprising calligrapher will be constantly on the look out for interesting papers and paints: what doesn't suit one assignment may be just the thing for another. There are several brands of calligraphic ink, made especially for the purpose but they are not all equally suitable. Waterproof inks are seldom any good for pen-written script but they are very useful in other ways for decoration and drawn lettering. It is wise to experiment widely. There are those, of course, who advocate the use of vellum or parchment, who delight in cutting their own quills and grinding their own pigments, who use gold and other precious metals for illuminated work. Such traditional mysteries in experienced

hands can be used to produce magical results. They do not, however, fall within my scope here. My concern has been to explore ordinary methods and materials and to present a range of small-scale works which will be immediately accessible to those of you anxious to put newly acquired skills to use. If you have worked hard to master some basic alphabets, and feel you have just about got the hang of it, you may well be wary of trying, for example, to write out all the Ten Commandments. There are all manner of interesting and useful projects along more modest lines which will greatly impress the uninitiated, and will provide the calligrapher with a satisfactory means of developing a more confident and expressive style.

The real scribes, I suppose, are those who can write out a lengthy proclamation and get it right first time — or, at any rate, it will *look* pure and blameless from the beginning as though it had arrived 'all of a piece', and only the scribe himself will remember the blood, sweat and tears that went into one trial run after another. Calligraphy as an art form seems to call for some such attempt at perfection.

I regard myself, not so much as a scribe, but as a sort of jobbing calligrapher. Much of my work is for print, and when something appears in print no one knows which bits may have been enlarged or reduced, no one can see all the patchwork covering up the parts that went wrong or the places where I simply changed my mind. Print processes and the photocopier can absolve what might once have been regarded as calligraphic sins: they have given us new opportunities and a new flexibility.

"A man may write
at any time if he
will set himself
doggedly to it."

SAMUEL JOHNSON

BASIC FORMAL ALPHABET

The history of calligraphy is strewn with straight-laced people who from time to time have laid down all manner of rules and regulations about how it should be done. We soon find, however, that the experts do not always agree with one another, and thankfully there have also been those who believe that laws are made to be broken. In any case, letter forms, however firmly established, tend to undergo all sorts of subtle mutations over the years: with constant use they adapt themselves to changing needs.

Now, with the rediscovery of scripts from other times and other cultures, the modern scribe has access to many different alphabets. These voices from the past still speak with a discipline and a magic of their own. They deserve to be treated with respect, but we need no longer be enslaved by them. By all means let us study classical forms: you will find it useful — maybe essential — to master a basic formal alphabet, but you need not feel that you have fallen into grave error if it is not precisely what Edward Johnston or Alfred Fairbank might have recommended. It is far more important, these days, that we have the courage of our own convictions.

The example offered here, despite its medieval roots, belongs to no particular time. It is a 'general purpose' script, combining legibility and decoration.

A B C D E F G

H I J K L M N

O P Q R S T

U V W X Y

&Z

1 2 3 4 5 6 7 8 9 0

a b c d e f g h i

j k l m n o p q

r s t u v w x

y z

RUSTIC CAPITALS

This nonchalant form of Roman is a very practical style, easy to read and not too laborious to produce. It still serves for the occasional political poster just as it probably did when it first evolved, although these days it may be better to use a poster pen or a wide flat brush rather than a sharpened reed, and a sheet of cartridge paper might not be considered an extravagance. The Romans may well have written directly on the wall — no point in using expensive papyrus unless you have to.

Whether you are advertising a jumble sale or a chariot race, the Rustic alphabet is a very serviceable script. It is somewhat condensed and economical in its use of space, and is probably at its best when written with one of the broader pen sizes for short bold statements, rather than long passages of continuous reading matter.

The term Rustic distinguishes the style from the more formal proportions of Monumental Roman, but it is certainly not meant to imply that these capitals are in any way uncouth. On the contrary they can be written with great elegance, and the overall texture can be exploited for its decorative effect.

The numerals on the bottom line are a more modern invention.

ABCDEFGH
IJKLMNOP
QRSTUVW
VIII IX XYZ
1234567890 ?

HALF-UNCIAL

This chunky rounded style seems immediately to take us back to the eighth century or earlier, but there is nothing obscure about it. Half-uncials make a very satisfying texture when used for compact longish passages, but they cannot be written very quickly. They have an unhurried deliberate appearance, and their shallow pen angle (the pen is held almost vertically) makes them especially suitable for many left-handed scribes.

Most of the older calligraphic styles do not look out of place in a religious context. This is scarcely surprising since calligraphy only survived some of the darker centuries because of the devotion of the monastic scribes. As self-supporting communities the monasteries provided some measure of stability in tumultuous times so that lengthy projects such as the writing of the gospels stood some chance, however slender, of being finished. What sometimes prevented them from being finished was the intricacy of the illumination which seems to have been more important than the accuracy of the text.

Half-uncials have nevertheless come down to us with all their Celtic and monastic associations. They still serve admirably for documents with any liturgical or historical connection.

a b c d e f g

h i j k l m n

o p q r s t u

v w x y z

ITALIC

The term Italic is usually applied to a condensed and slightly sloping style which, in its cursive form, can be written fairly quickly. It has therefore been adopted as the basis of an everyday form of handwriting. Its main characteristic, however, is its buoyant springing rhythm which can also be achieved with upright letters.

It is a scholarly style, equally suitable for short captions or for longer, more formal, inscriptions. The capitals can easily be extended to make flourished or swash characters, and about half of the minuscule letters automatically reach forward to touch on to the next letter to form word units. Like beads on a necklace letter units are most effective when linked to make continuous statements. It is tempting to exaggerate the graceful ascenders and descenders, but the overall balance of a piece can easily be upset if individual letters attract more attention than they deserve.

When teaching children how to write, the problem is to foster neatness and legibility without imposing a dreary uniformity. Teachers have tended to be dogmatic, even tyrannical. The spread of printing in the sixteenth century enabled the writing masters to circulate precise instructions for a variety of scripts, mostly elegant, but owing as much to the engraver as to the scribe. In Victorian times children were often drilled in a sort of copperplate — a very beautiful but difficult style produced with a flexible pointed metal nib. In the present century, with renewed interest in the quill and the chisel-shaped nib, the revival of Italic script has brought order to the teaching of handwriting now that there is so much else for infants to learn. The subsequent arrival of the ubiquitous ball-point promises now to upset any laws which may have been laid down and, in any case, children these days probably learn how to press buttons before they learn how to draw letters. Beautiful writing is still a desirable skill, but I am comforted to find that even the most accomplished scribes often have their own everyday scrawl like most other people.

A B C D E F

G H I J K

L M N O

P Q R S T

U V W X Y

Z

a b c d e f g h i j

k l m n o p q r s

t u v w x y z

1 2 3 4 5 6 7 8 9 0

VERSALS

Authentic versals would be written with a chisel-shaped quill or nib, and would therefore display some variation between thicks and thins. The example shown here is a simplified version written with a pointed marker pen, not a 'calligraphic' marker: the result is rather more modern and mechanical, but it is easier to be decisive when using an implement which will not 'break down under pressure'. These are therefore 'drawn letters' rather than 'pen letters'.

Versals can be used in conjunction with most other styles: they work well singly as initials and can be coloured and filled in. They can also be used as continuous capitals for complete lines or titles. The shapes are simple and legible, similar to Roman monumental capitals, but drawn more quickly with greater spontaneity. A very delicate and slender form can be used to create an alphabet of great dignity and elegance.

(See Calligraphic Playing Cards on page 91.)

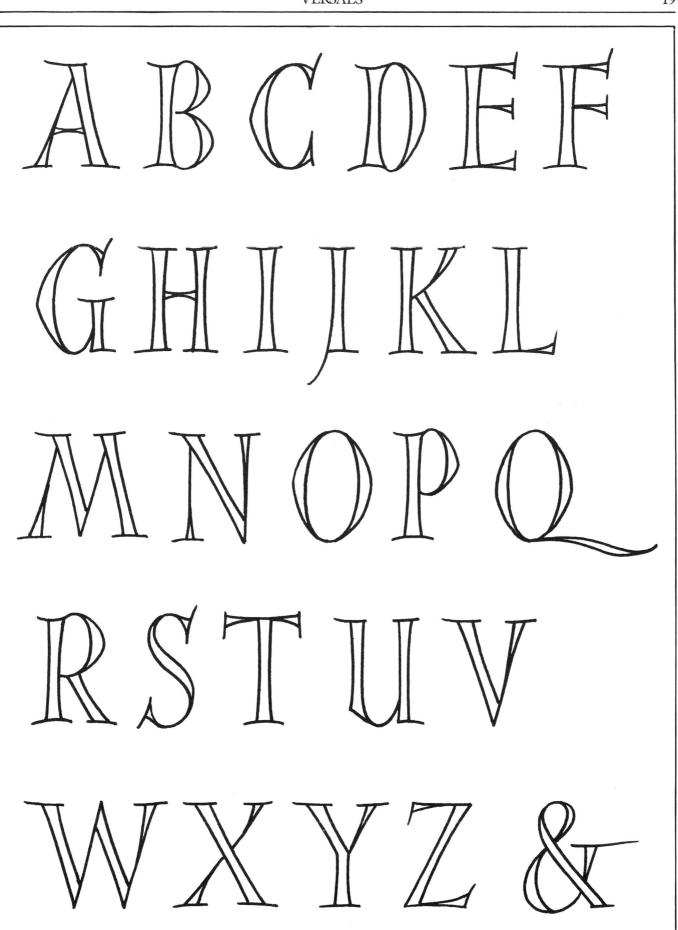

LOMBARDIC

This alphabet has also been drawn with a pointed marker pen — an implement unknown in Lombardy when these letters first evolved. They are, so to speak, bloated versals, and because of their swollen proportions there is plenty of room for elaborate decoration. Letters such as these are the basis for many a richly illuminated initial: they should be used sparingly since it is always possible to have too much of a good thing.

Lombardic initials can be combined to make monograms or worked in unusual materials such as cut paper, icing sugar or embroidery. There is even room to incorporate pictorial matter within the lines of the letters themselves.

These are adaptable letters: their character

changes with the colour and form of the decoration applied to them. When painted with only one or two restrained tones and combined with a sober text, they can enliven a serious inscription without making it look any the less devotional. If, on the other hand, the letters are loaded with bright colours and patterns they begin to take on a kind of carefree fairground quality.

A catalogue of transfer letters or printer's typefaces will sometimes suggest appropriate forms of decoration. Over the years types tend to become identified with certain traditional situations — the circus, the market stall, the seaside, and so on. Look out for greengrocers' gothic or ticket collectors' copperplate.

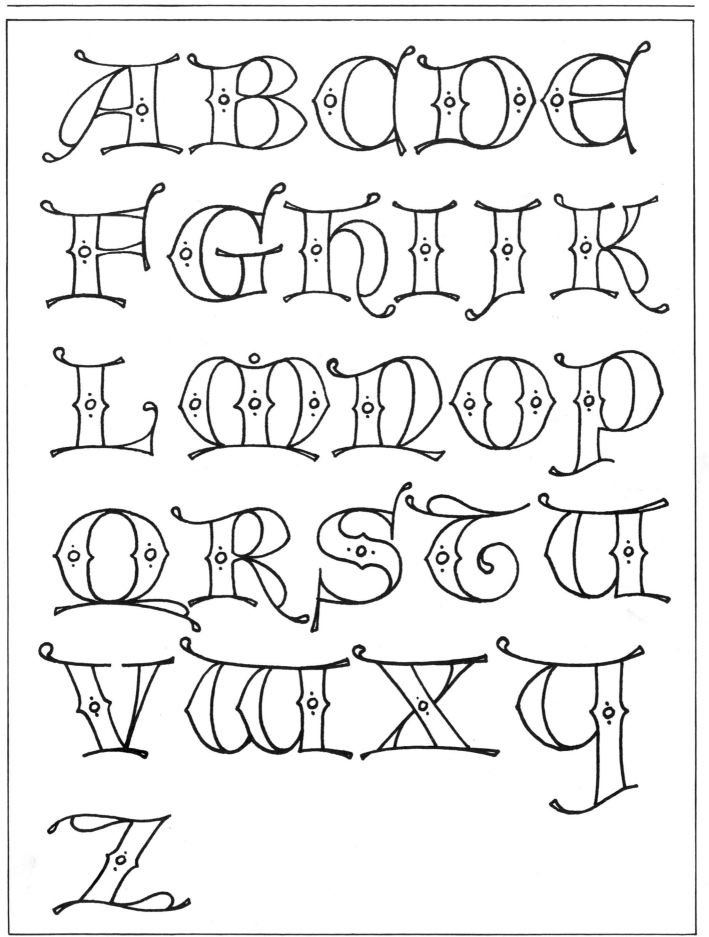

MODERN

It is difficult to put any specific name to this style. There are hundreds of different type faces in current use and I would hesitate to claim that this conforms precisely to any one of them. It is, however, typical of the kind of thing that happens when versal letters are drawn in a simplified way and with the aid of a ruler.

Such Modern styles, despite their impersonal appearance, do have their uses, and different kinds of decoration can be applied to them. Many calligraphic styles tend to look 'old-fashioned' which is scarcely surprising when we remember that they had their origins centuries ago. There are times, however, when the calligrapher may be asked to produce a poster or some other document where traditional forms would be inappropriate.

The style shown here could be drawn 'free-hand' using waterproof marker pens — a useful technique if the work is for display outside.

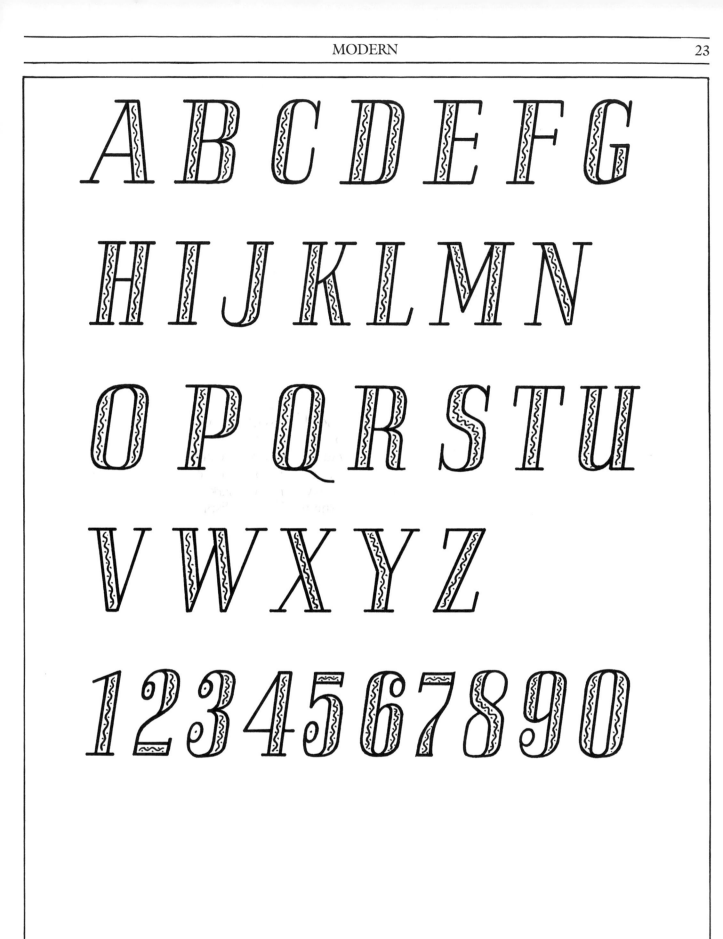

GOTHIC

A favourite style for antique shops and 'Tudor' tea rooms, this is one of the most decorative scripts — and one of the most difficult to read. There are many variations. It is said that the condensed and angular form shown here developed in order to make the most economical use of expensive vellum or parchment. It is essentially a product of the broad-edged quill so it is perhaps curious that it was the style adopted by the earliest printers.

Gothic or Black Letter needs to be written decisively. The capitals are very ornate and should be used sparingly: their solid black strokes may be embellished with hair line decoration originally produced with the broad-edged quill drawn sideways. These days fine-line marker pens or pointed nibs are probably easier to manipulate.

Because it is not easy to read, this style is now seldom used for long passages. It is ideal, however, for short statements such as conventional greetings where the message is obvious, whether legible or not. The repetitive verticals have been described as like the black notes on a piano or the uprights of a paling fence. You should eventually become so familiar with them that you can take structural liberties without constantly referring to prescribed examples.

A B C D E F G

H I J K L M N

O P Q R S T U

V W X Y Z

abcdefghijk

lmnopqrstu

vwxyz

BOTTLE LABELS

Home-made wines and beers suggest their own distinctive labels. Some basic titles and borders could be photocopied: then dates and details of individual vintages could be written in by hand. Try to imagine how the label will look in relation to the curved surface of the bottle. Use an adhesive, such as a glue stick, that will not cause the paper to wrinkle.

The wine bottle overleaf has two labels — a rectangular one written in Italic, and a smaller circular one with a Lombardic monogram. The beer label combines two styles — a pen-written Basic Hand, and Versals drawn in outline and filled in. The gin label uses two sorts of Gothic — one pen-written and the other drawn in outline after the style of an engraver's letter.

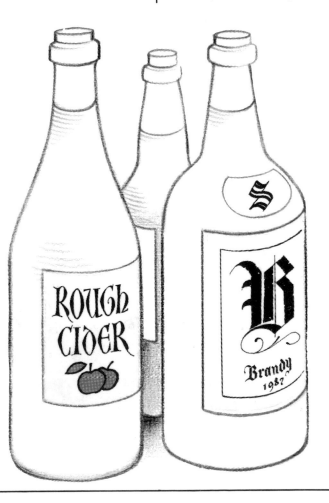

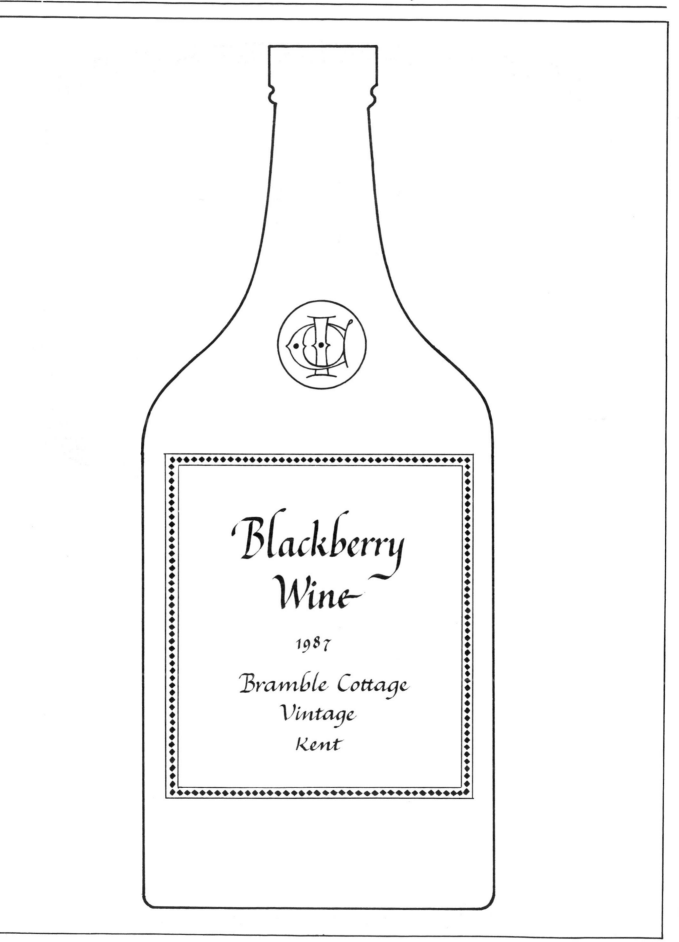

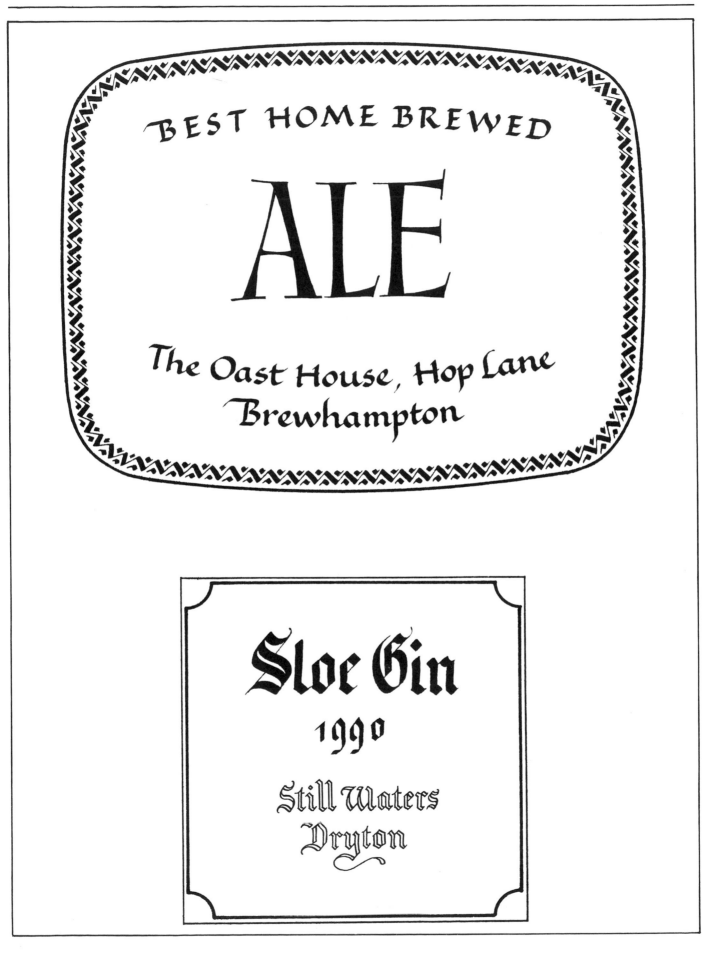

BEST HOME BREWED

ALE

The Oast House, Hop Lane
Brewhampton

Sloe Gin

1990

Still Waters
Dryton

JAM LABELS

The lettering here has been kept very simple for the sake of legibility. Interest can be achieved by varying the layout, by using different nib sizes, and by creating decorative borders. If the wording is to be centred it is often a good idea to write each line experimentally on a separate piece of paper to find out precisely how long it will be. Tacky address labels may be useful for smaller jars but they are seldom big enough for the larger ones.

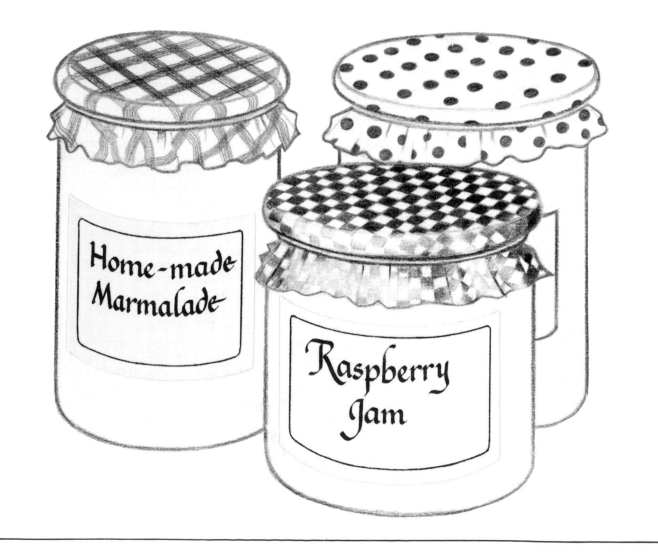

Home made

Plum Jam

1987

Pip Lodge , Flavouringham

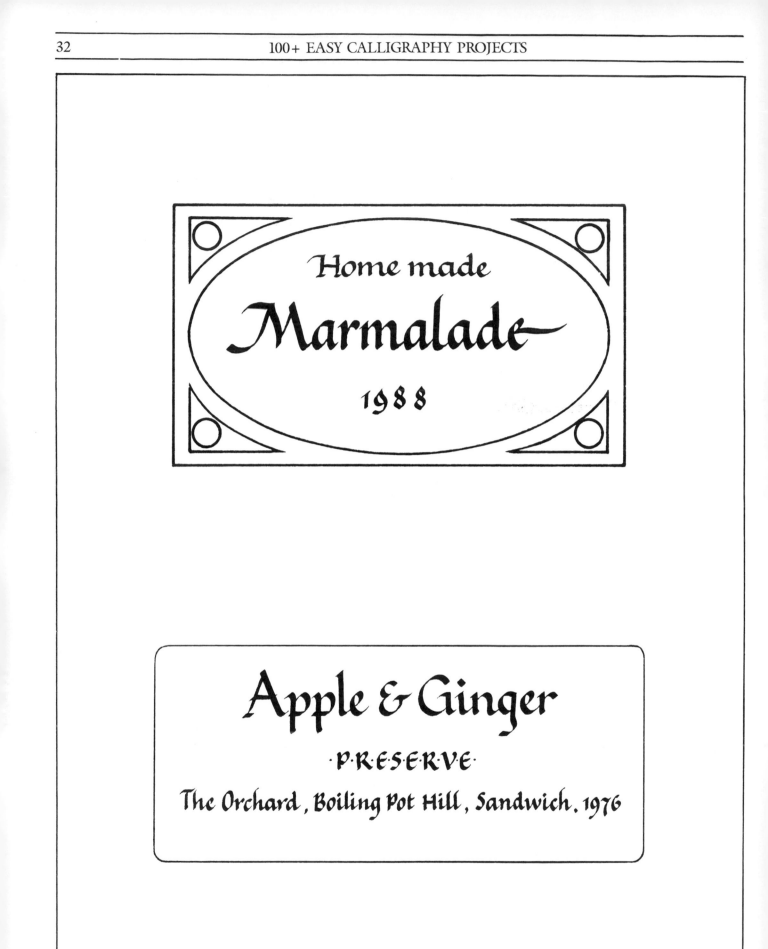

MORE IDEAS FOR LABELS

Even commercially packaged provisions when intended as presents can be given a more personal look with specially written labels.

When the lettering is highly decorative as in the case of this Gothic example below it may be wise to keep the border simple and unadorned.

It is not always necessary to make the border into a complete box: a decorative strip above and below may be sufficient as in the Half-uncial example on this page. The choice of colour in this sort of situation may be quite important so that there is a balance between lettering and ornament.

Sometimes there may be an opportunity to make a richly ornate feature of one initial. The one below has been drawn with a pointed marker pen on a pencil sketch which was then erased.

Whilst this short-hand version lacks the precision and fine drawing that may be found in early Celtic

manuscripts, it does make a bold calligraphic statement and provides a framework for applied colour. Sweeping curves are best drawn quickly and confidently or with the help of instruments (templates or a flexible curve). 'He who hesitates is lost'.

Although the next example might at first be taken to read either as 'Toffee' or 'Coffee' the first letter is, of course, a Gothic 'T'. Double-line pen work can be done with special 'two-stroke' nibs. Large calligraphic markers can sometimes be cut with a sharp scalpel to produce two lines instead of one.

Here, however, the letters have been built up with single pen strokes, providing good practice in drawing close parallel lines. The flourishes beneath should look spontaneous, even if they were not.

Three ways to use simple calligraphic borders are shown here.

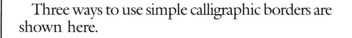

Old engravings — or new ones for that matter — usually look quite 'at home' with a pen-written script. Old catalogues and illustrated books may turn out to be gold mines of suitable material. If you intend to reproduce illustrations try to make sure that they are no longer protected by copyright (as modern ones would be).

There is no need to ruin old volumes by cutting them. The modern photo-copying machine can sometimes actually improve the quality of old engravings, and can enlarge or reduce them to fit the job in hand. The same motif, in different sizes, could be used on several related documents in much the same way as a trade mark.

EXPRESSIONS OF GRATITUDE

All the different ways of saying 'Thank you' provide calligraphers with many an opportunity to use their talents. Choose a style and format to suit the occasion: it may be a card or notelet, or a tag to accompany flowers or chocolates, or a special wrapping paper.

The following two Italic examples make use of flourished letters. Since the message itself is quickly grasped there is little fear of confusing it by the addition of extra pen strokes.

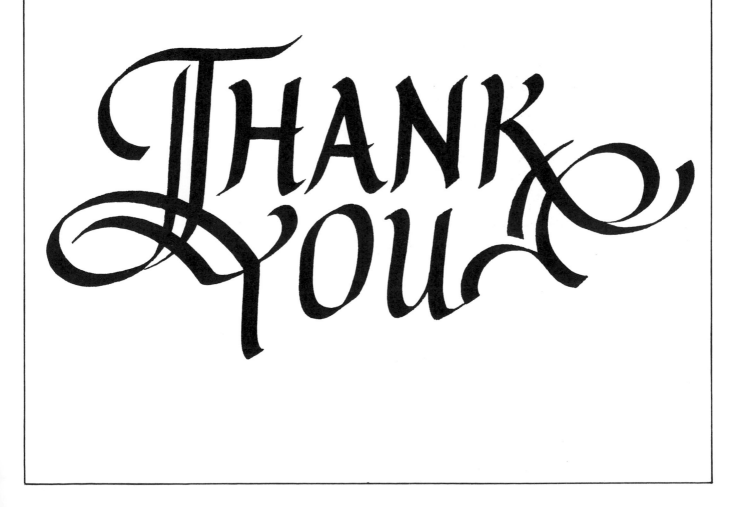

Thanks for the memory

Small cards or tags bearing only a word or two inevitably concentrate attention on the quality of the writing and the quality of the card. The shade, weight, and texture of the writing surface are significant features of any inscription, but even more so when the area is small. I find that off-cuts from larger jobs can often be used to good effect for this sort of work. Some of the rough-surfaced watercolour papers, however, tend to produce ragged pen strokes which, whilst they might be attractive in a large piece of work, are maybe not so desirable on a small card. It is usually possible to make the surface smoother by burnishing: place a piece of tracing paper over the watercolour paper and press firmly with some hard smooth implement such as a spoon handle.

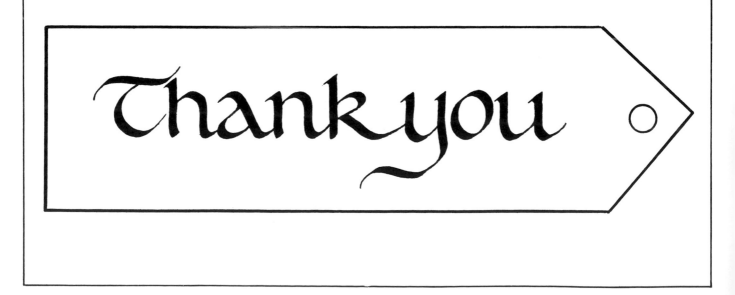

Reversed lettering — white on colour instead of the other way round — can be produced in several ways. A negative photographic print could be made from a positive original. Alternatively, the lettering could be done with white paint, but the difficulty then is to dilute the paint sufficiently to flow in the pen without making it so thin that it will not cover the background colour.

The example here was done in neither of these ways: the letters were first drawn in outline, black on white, and the background was then filled in, using a fine brush, leaving the letters themselves untouched.

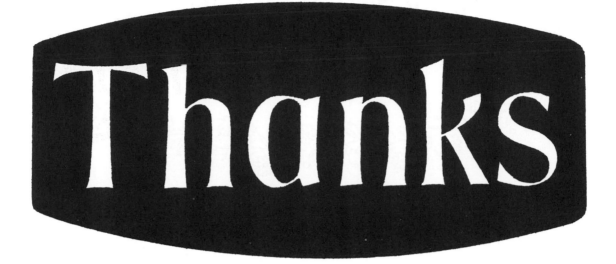

This Uncial version demonstrates how the invention of one sort of writing instrument may have an effect upon letters which originally evolved from the use of another. Uncials, probably derived in the first place from Roman capitals, were more rounded and chunky, resulting from the use of a chisel-shaped quill or reed pen. The main word in this inscription, however, has been drawn in outline with a pointed fibre-tip or marker pen, an implement which the early Christian scribes might have thought miraculous. The resulting contradiction is a style combining ancient and modern which could be outlined in one colour and filled in with another.

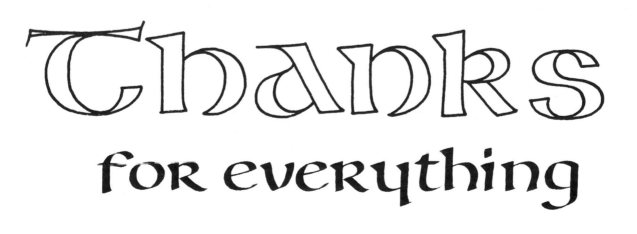

Here we have a floral garland for a border, drawn freely with a pointed nib, ready to be loosely coloured with crayons, inks, or watercolours. The lettering, also drawn with a pointed marker pen is in Versals, without any serifs — still perfectly legible but rather more modern than the serifed version.

The heart-shaped border is drawn very simply — one half being traced from the other to ensure symmetry. The lettering within is also uncomplicated, although the capitals have been freely interpreted.

WRAPPING PAPER

Producing your own wrapping paper is perfectly feasible although the area of a single sheet will depend upon the capacity of your photo-copier. Most machines seem to take up to A3 which is just about big enough to wrap a book of average size. First design a unit comprising one or two words with some expressive ascenders and descenders. Make a few rough pencilled tracings for purposes of experiment to see whether the units will fit together comfortably — a process called 'step and repeat'. When you are confident that the unit will work, photo copy it about fifty times. (By copying a few and doubling up each time this can soon be achieved). Cut out all the copies as close to the lettering as possible. Then arrange all the copies in the form of a regular closely-knit pattern and stick them down to make a master sheet from which any number of sheets can be copied, possibly in colour on a tinted ground.

Several units, as described above, can be arranged to make a circle or some other straightforward geometrical shape. Such multiple units, possibly combined with some sort of motif or illustration, can be used as designs for greetings cards or letter paper.

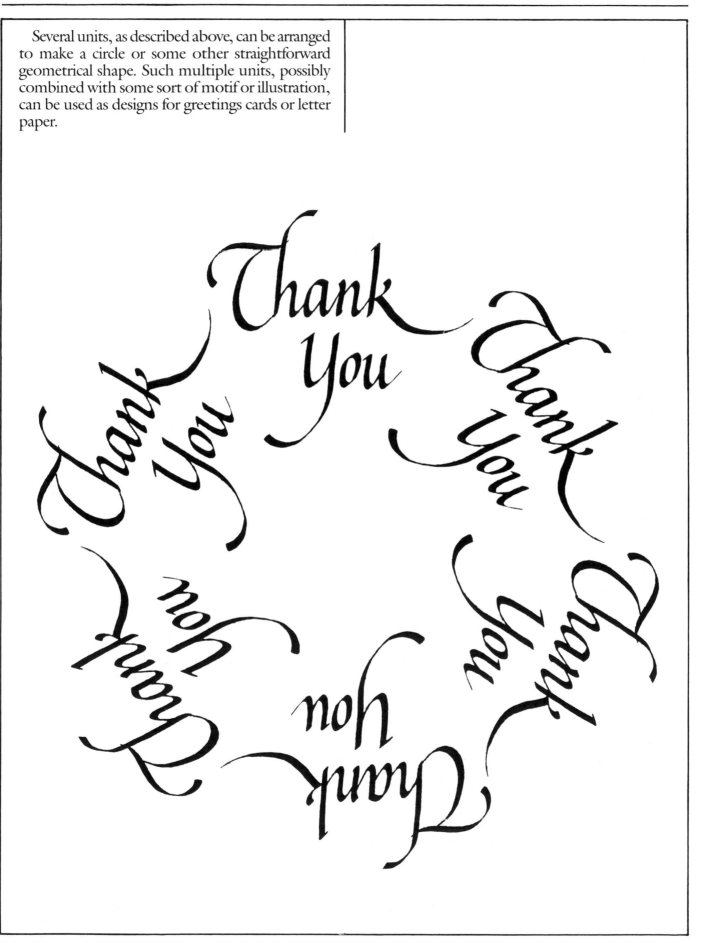

PACKAGING

'Nets' for boxes can be drawn on stout paper or card, decorated and inscribed whilst flat, and then cut out and assembled to make containers as small gift boxes. Rectangular boxes require six panels with flaps in all the appropriate places: these must be measured precisely if the box is to fit together, and the folding lines must be scored to fold sharply. Designs may be reproduced by photo-copying if the machine will take paper that is sufficiently thick. This system could produce sufficient quantities for craft fairs or cottage industries but mass production is scarcely feasible so long as boxes have to be cut out individually by hand. A fairly foolproof method of dealing with the layout is to take a printed carton and carefully dismantle it: open it out; lay it out; and draw round it with a sharp pencil. A quick look along the shelves in the supermarket will reveal all manner of different cartons — toothpaste boxes, pie boxes, soap boxes, cheese boxes, and so on.

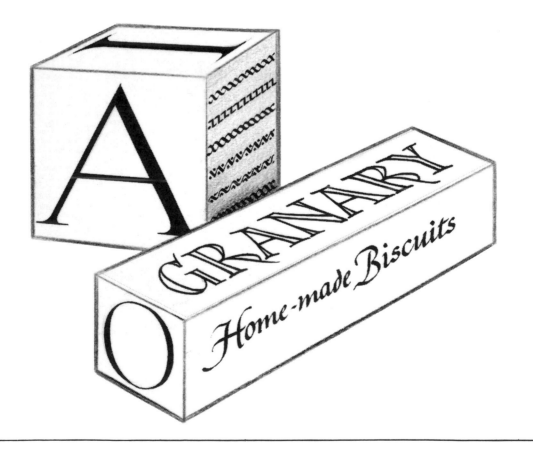

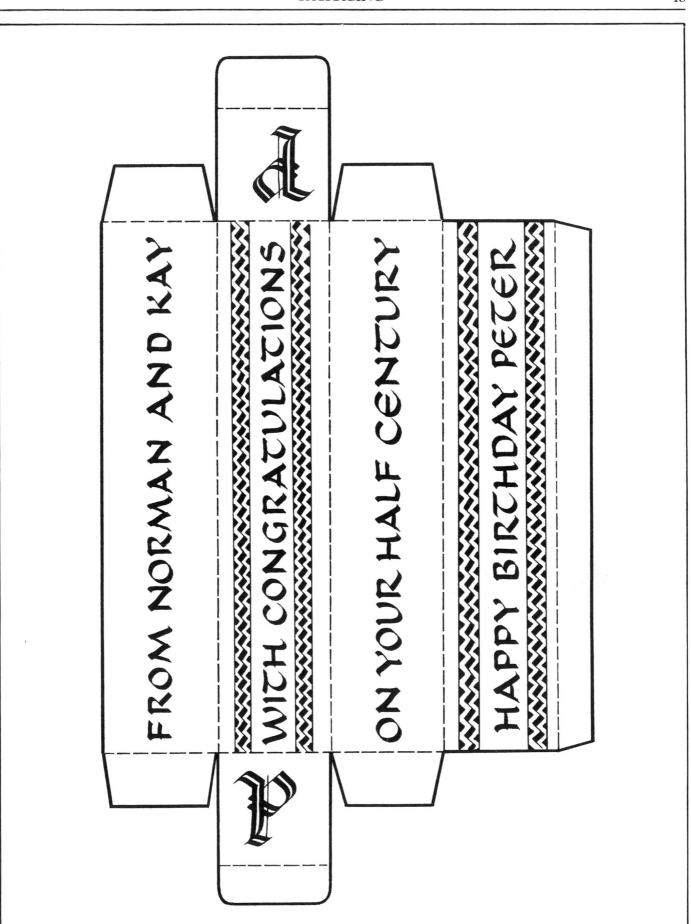

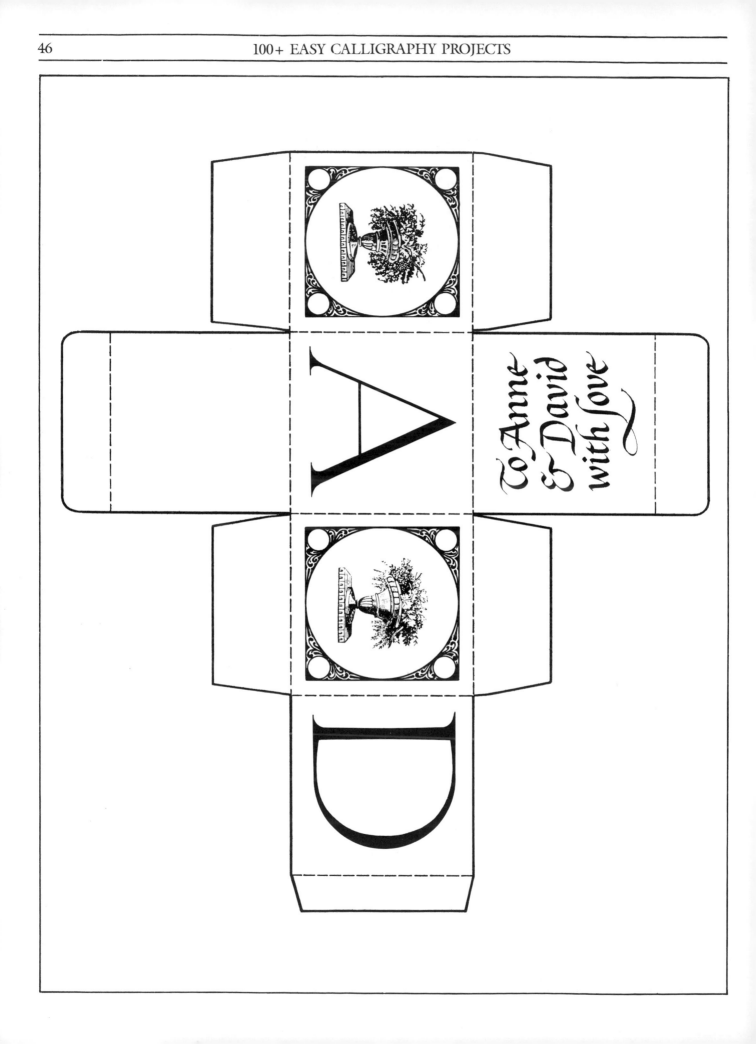

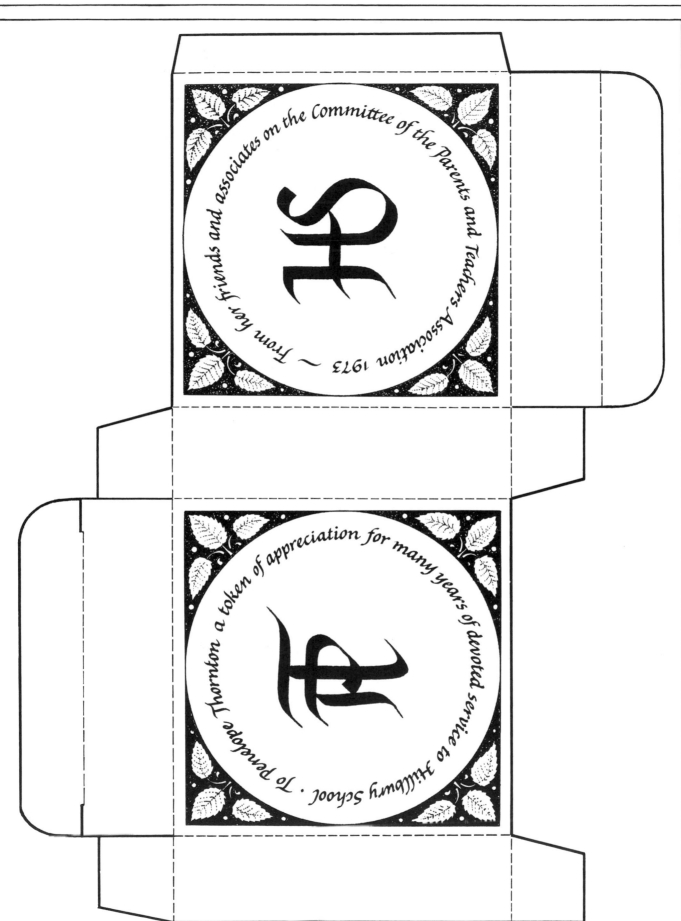

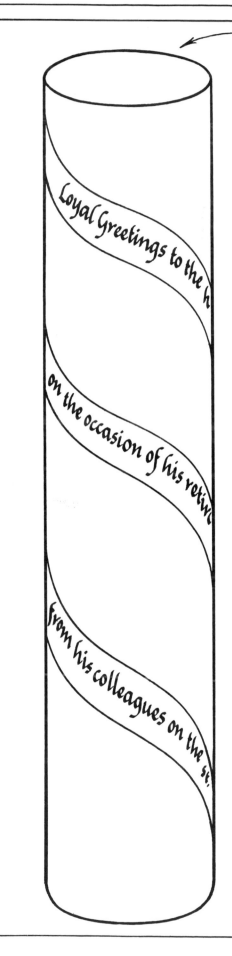

Scrolls and documents may be contained in a cardboard cylinder. Since it is difficult to write decently on a curved surface, one way of making an inscription on the outside of the tube is to write it on a ribbon of paper which can be wound round in a spiral. The ends of the tube, if it has plastic stoppers, may be adorned with a circular design, possibly combining monogram and a brief message.

BADGES

Lapel badges can also present the calligrapher with a small circular format. Blanks with pins already attached may be obtained from a stationer. Since they are for purposes of identification the writing should be clear and free from unnecessary embellishment. Children's parties, however, may call for a more relaxed approach: fun badges with names and funny faces in bright colours might then be more appropriate.

Situations calling for clear factual information are

FUNCTIONAL NOTICES

Situations calling for clear factual information are many and various. I show here some of the more obvious examples. For large notices I would use a flat brush; for medium sized notices I would use a marker or a poster pen; and for small desktop or office door notices a calligraphic pen or one of the smaller markers would probably be suitable. It is often not the size of the notice which demands attention, but the clarity of the writing and the amount of white space isolating it from its surroundings.

Clubs and Societies frequently need calligraphic writing for posters, notices, letter paper, programmes, and so on. Since clarity is usually the keynote, unadorned writing in some plain style is required. Resist the temptation to be over-elaborate. The judicious use of colour can sometimes aid legibility without confusing the message.

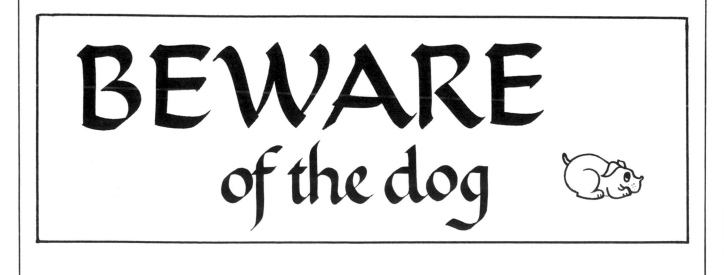

CONFERENCE OFFICE

RECEPTION ENQUIRIES

SURGERY CAR PARK

INFORMATION EXIT

WAITING ROOM OUT

IN CLOAK ROOM

STAFF ONLY PRIVATE

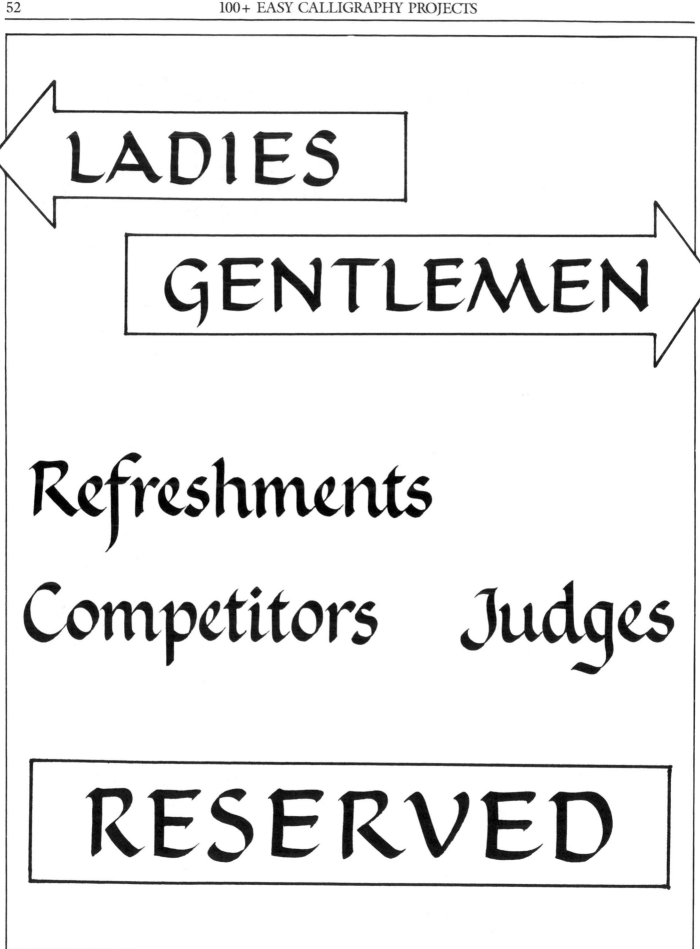

Sir Digby Snook

C H A I R M A N

Rev. John Porter

P R E S I D E N T

Mrs. Beryl Harvey

S E C R E T A R Y

Mr. Simon Gold

T R E A S U R E R

Mallowfield Horticultural Society

PLANT LABELS

These should clearly identify the plant without overwhelming it. If written on card they may need to be sprayed with fixative and covered with clear tacky film to protect the writing from moisture. Labels to be used outside should be written with a waterproof marker or with waterproof ink: this will not allow for much delicacy in the writing but even without thicks and thins well-proportioned lettering can be achieved.

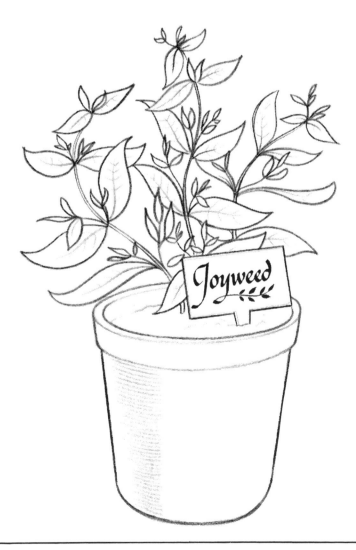

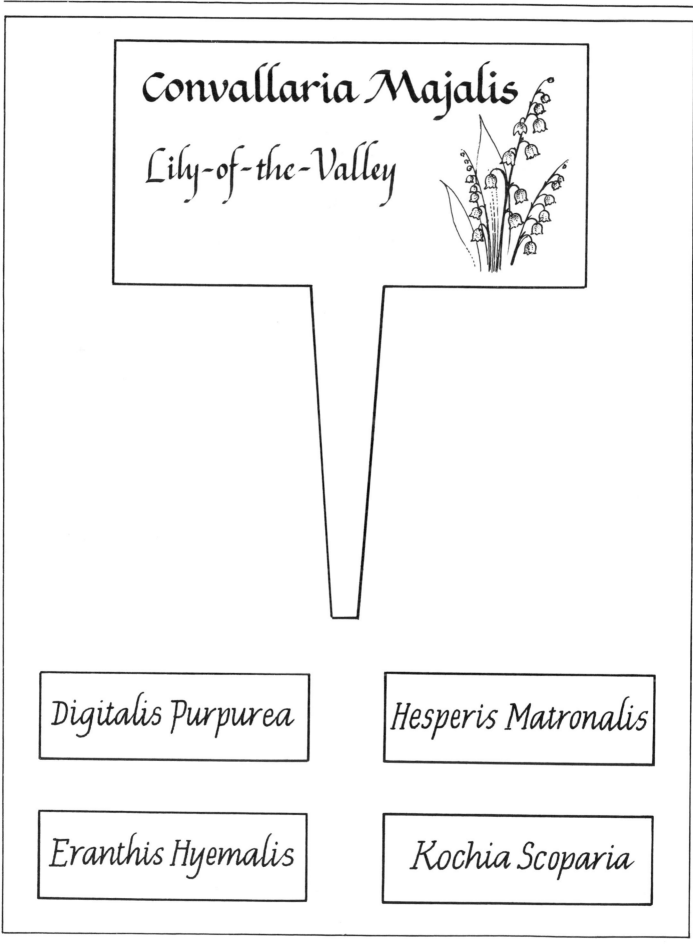

Convallaria Majalis

Lily-of-the-Valley

Digitalis Purpurea

Hesperis Matronalis

Eranthis Hyemalis

Kochia Scoparia

A GARDEN POSTER

Notices of this sort need to be clearly recognizable, even before they are read. The main heading on the example overleaf has therefore been written in a style that allows for decoration and the use of colour. Posters for local use are seldom required in enormous quantities, so they can be produced economically on the photocopier. Larger sizes can be copied in smaller sections which are then pasted-up together: thus four A3 components would make an A1 poster (841mm×594mm, or approximately 33 inches×23 inches.) Colour may be quickly applied with marker pens — spirit based for outside use.

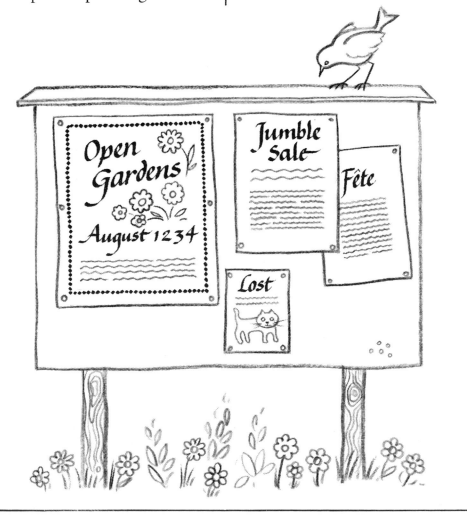

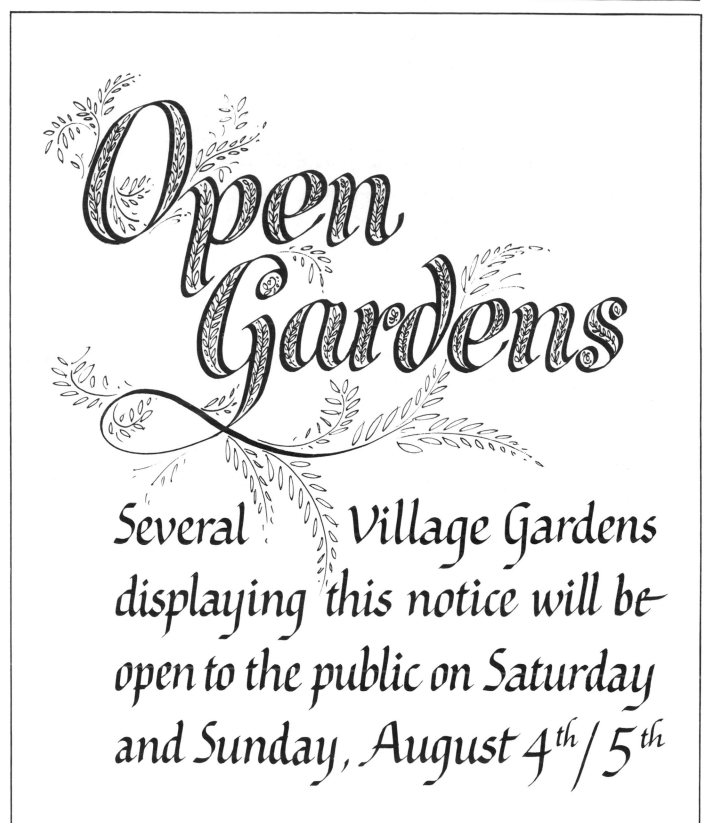

Open
Gardens

Several Village Gardens
displaying this notice will be
open to the public on Saturday
and Sunday, August 4th / 5th

Admission £2.50 Proceeds to St. Edmunds Organ Fund .

MORE READY-MADE ILLUSTRATIONS

It is perhaps usual for an illustration to be chosen or drawn in order to support the text. To reverse the procedure is to put the cart before the horse, but there are certainly occasions when the calligrapher might be inclined to seek words to complement a picture instead of vice-versa.

The illustration on page 60 is a brass rubbing, very much reduced in size. Monumental brasses are forms of engraving and, as has already been shown (see page 36), engravings and calligraphic lettering often go well together. Before taking rubbings from church monuments it is necessary to obtain permission, which might only be granted on payment of the appropriate fee. There are, however, brass rubbing centres, often attached to cathedrals, where rubbings may be made or purchased. Choose one of the smaller ones, reduce it still further by photocopying, and design the lettering round it.

On page 61 there is another rubbing, not from a brass, but from the embossed cover of an old book. Place a sheet of thin paper over the embossed design and rub firmly with a piece of black wax crayon, used sideways. Cut away any unwanted lettering and add some words of wisdom of your own.

The doubts of some
are more indicative
of a love of truth than
the belief of others—
They arise from a
sense of the awful
importance of the—
issue and an agonising
desire to be sure. But
wherever it interferes
with practical duty
it is wrong, for duty is
always incumbent
and it is God's way
of leading to truth.
. John Ker

RECIPES AND MENUS

We tend to become accustomed to working within a rectangular frame. To make the lettering conform to irregular shapes it may be necessary to plan the work rather carefully to make sure everything will fit. The recipes that follow were written out roughly with a pencil first. Pieces like these could be framed and hung on the kitchen wall, or they might be compiled in a loose-leaf binder. Work which is to be used for reference in the kitchen should be protected with clear tacky film which can more easily be wiped clean. These are followed by more examples where an irregular pictorial border imposes interesting restrictions on the layout.

If possible leave ample white space round the inscription itself. If the lines are to be centred, write out each one first on a separate sheet to determine how long it will be.

The basic silhouettes of wine glass and carafe could be cut from tinted paper and mounted on card. A distinctive shape aids identification. The lettering is kept very simple.

The shape of the house immediately lends an informal note to the example of an invitation on page 65.

The decorative frame or cartouche on page 67 has been borrowed from another old engraving. Old maps are a rich source of inspiration.

The use of a gimmick such as the plate, knife and fork drawing on page 66 need not detract from the dignity of the writing. The cutlery is drawn from late 18th-century examples and the style of decoration on the handles has also been used to enhance the lettering of the title.

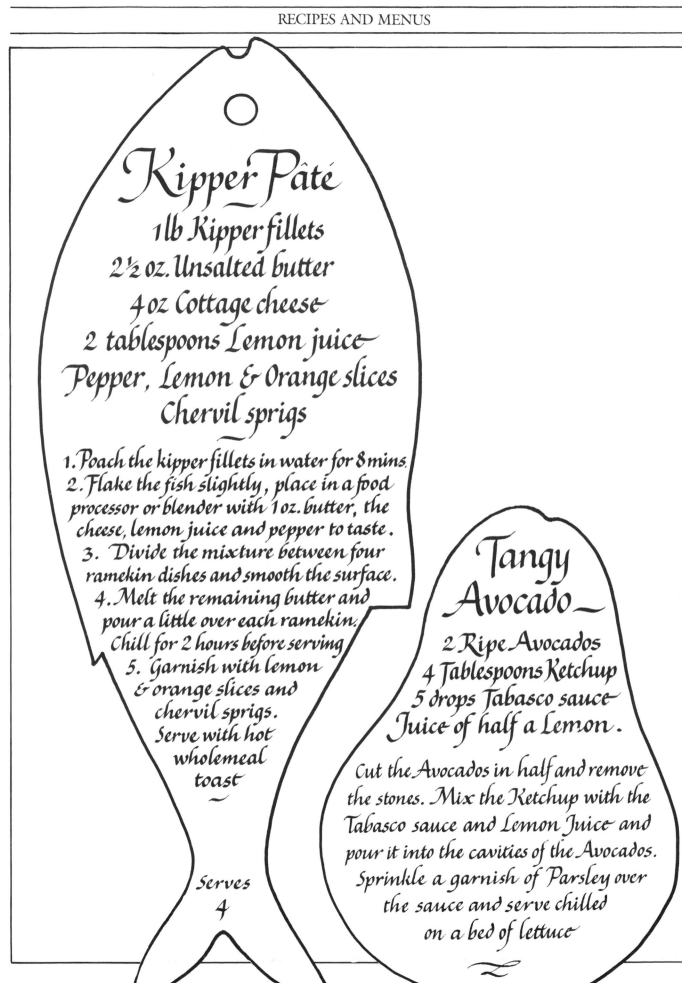

Kipper Pâté

1lb Kipper fillets
2½ oz. Unsalted butter
4 oz Cottage cheese
2 tablespoons Lemon juice
Pepper, Lemon & Orange slices
Chervil sprigs

1. Poach the kipper fillets in water for 8 mins.
2. Flake the fish slightly, place in a food processor or blender with 1 oz. butter, the cheese, lemon juice and pepper to taste.
3. Divide the mixture between four ramekin dishes and smooth the surface.
4. Melt the remaining butter and pour a little over each ramekin. Chill for 2 hours before serving
5. Garnish with lemon & orange slices and chervil sprigs. Serve with hot wholemeal toast

Serves 4

Tangy Avocado

2 Ripe Avocados
4 Tablespoons Ketchup
5 drops Tabasco sauce
Juice of half a Lemon.

Cut the Avocados in half and remove the stones. Mix the Ketchup with the Tabasco sauce and Lemon Juice and pour it into the cavities of the Avocados. Sprinkle a garnish of Parsley over the sauce and serve chilled on a bed of lettuce

Menu

Melon
Prawn Cocktail
Sorrel Soup

·

Sea Food Assortment
Fish Pie
Curried Egg Cutlets
Savoury Potato
Vegetable Fricassee
Mixed Salad

·

Gooseberry Meringue
Victoria Plum Charlotte

·

Cheese & Biscuits

·

Coffee

·

Wine List

Volari Bianco
Pinot Noir, Inglenook
Merlot, Vin de Pays de l'Ardeche
Julienas, Domaine de Beauvernay
Diego de Almagro, Valdepanas
Rose d'Anjou, Pierre Picard
Graves, Laurent Lescure
Les Deux Rives

Wine List

Served by the Glass
Riesling 60p
Chardonnay 70p
Mateus Rosé 1.00p
Niersteiner 80p
Chianti 50p

Marker Pens seldom give the same precision as a lettering nib, but they are very suitable for bold colourful inscriptions, especially when required in a hurry. Many calligraphers will remember early exercises using two pencils bound together with tape. The same thing can be done with two pointed marker pens. Write as though using a chisel-shaped nib, keeping the pen angle constant. At the end of a stroke turn the implement on to one point only in order to enclose that part of the letter. This method produces outline letters about two inches high — large enough to use on posters.

Coloured markers might be used to decorate or fill in individual letters.

Calligraphic markers are chisel-shaped and will generally produce letters with quite a high degree of definition. They are usually firm and inflexible and will not distort under reasonable pressure, so they can be recommended for the heavy-handed. Although it should never be necessary to press very hard, some people find it helpful to do so in order to achieve a decisive confident script.

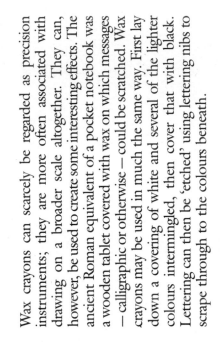

Wax crayons can scarcely be regarded as precision instruments; they are more often associated with drawing on a broader scale altogether. They can, however, be used to create some interesting effects. The ancient Roman equivalent of a pocket notebook was a wooden tablet covered with wax on which messages — calligraphic or otherwise — could be scratched. Wax crayons may be used in much the same way. First lay down a covering of white and several of the lighter colours intermingled, then cover that with black. Lettering can then be 'etched' using lettering nibs to scrape through to the colours beneath.

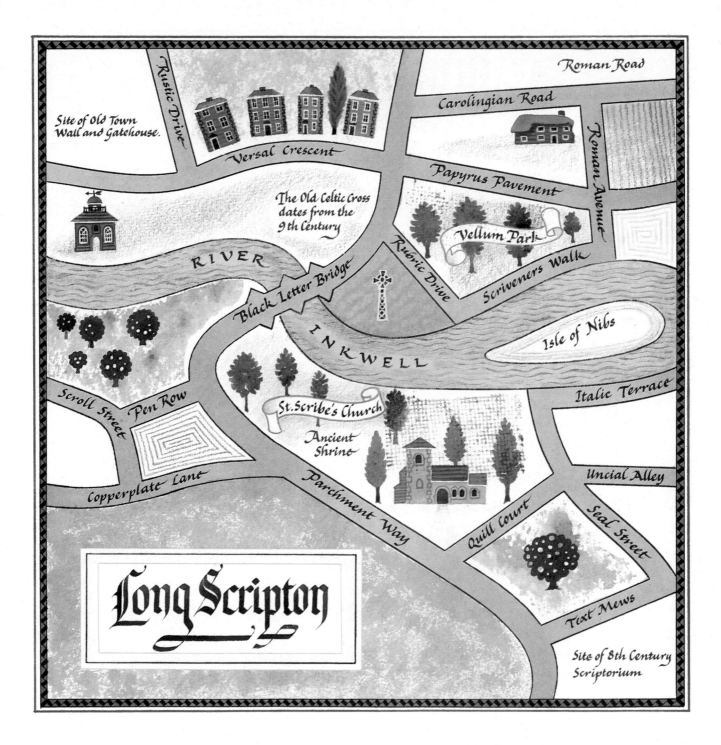

The map shows the town of **Long Scripton** with the following labelled features:

- Roman Road
- Rustic Drive
- Carolingian Road
- Site of Old Town Wall and Gatehouse.
- Versal Crescent
- Roman Avenue
- Papyrus Pavement
- The Old Celtic Cross dates from the 9th Century
- Vellum Park
- RIVER
- Rubric Drive
- Scriveners Walk
- Black Letter Bridge
- INKWELL
- Isle of Nibs
- Scroll Street
- Pen Row
- St. Scribe's Church
- Ancient Shrine
- Italic Terrace
- Copperplate Lane
- Parchment Way
- Uncial Alley
- Quill Court
- Seal Street
- Text Mews
- Site of 8th Century Scriptorium
- Long Scripton

Maps provide all sorts of wonderful opportunities to combine information and decoration. It might simply be a sketch to show someone how to get to your house, or it might be something more elaborate — a plan of a whole area with various landmarks drawn in detail, or it might be an entirely imaginary place — a dream world, a treasure island, or a historical reconstruction.

Old maps are a rich source of material; not only different kinds of engraved lettering, but cartouches, compass-point diagrams, topographical pictures and borders may all be found in abundance.

An Italic style is very serviceable when words have to be bent round corners or squeezed into awkward places. Inscriptions entirely in capitals should perhaps be used sparingly with plenty of letter-spacing. Drawings of buildings and trees are more manageable as flat facades rather than perspective pictures, and background areas may be simply textured by sponging, pencil shading, or 'printing' from scraps of canvas.

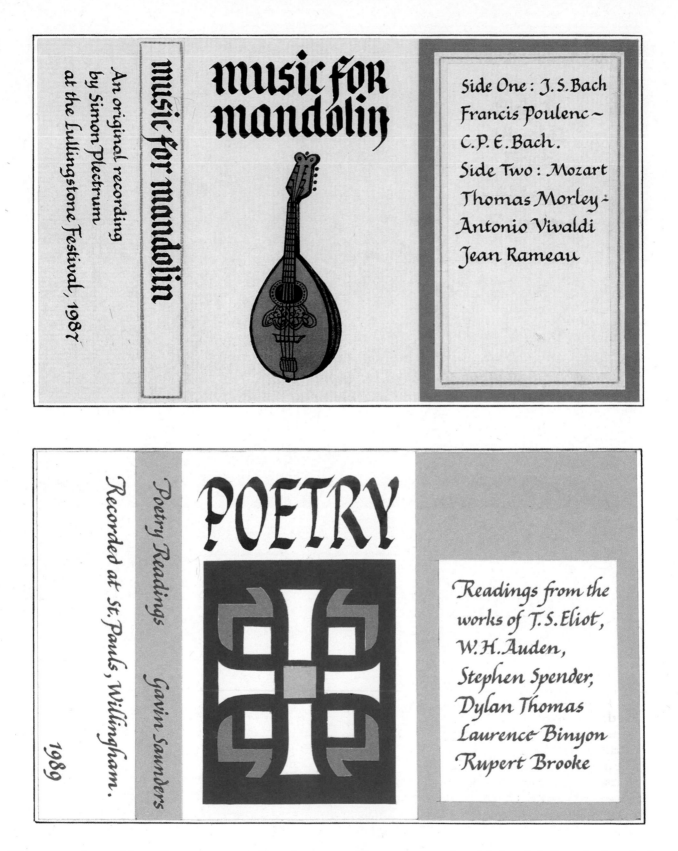

music for mandolin

music for mandolin

An original recording
by Simon Plectrum
at the Lullingstone Festival, 1987

Side One: J. S. Bach
Francis Poulenc ~
C. P. E. Bach.
Side Two: Mozart
Thomas Morley ~
Antonio Vivaldi
Jean Rameau

POETRY

Poetry Readings Gavin Saunders

Recorded at St. Pauls, Willingham.

1989

Readings from the
works of T. S. Eliot,
W. H. Auden,
Stephen Spender,
Dylan Thomas
Laurence Binyon
Rupert Brooke

Now that the making of amateur recordings is so straightforward it seems to be increasingly used as a means of communication between friends in much the same way as letter-writing used to be. The exchanging of cassettes provides an opportunity for the exercise of calligraphic skills as well. The design area is small, so the message should be brief and the design uncomplicated. The musical example here combines a Gothic script and a simple drawing in coloured ink. The poetry example employs Rustic Capitals and a papercut design with supporting matter in Italic.

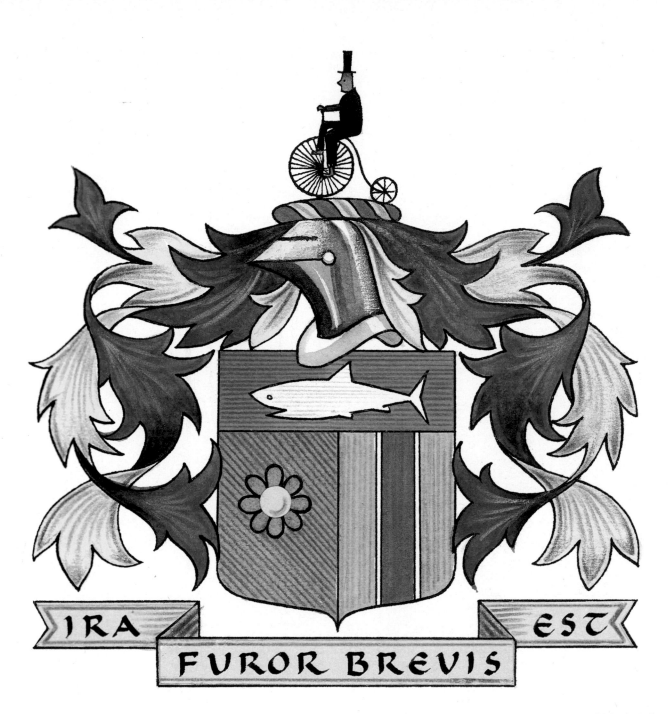

IRA EST

FUROR BREVIS

Heraldic designs always conform to a precise code. The calligrapher, therefore, must never take liberties with the content or arrangement of any coat of arms, which he or she may have been commissioned to reproduce, since it may well have been officially registered and granted to a particular family or society whose property it is. Armorial bearings describe their ancient lineage, and originally served as a means of recognition on the battlefield, when chivalry demanded that everyone should keep strictly to the rules.

There is some freedom in the style of lettering and in the flowing lines of all the 'sea-weedy' business round about, and in the overall proportions, but other components must not be altered. There are seven heraldic colours including the metals, gold and silver.

The others are red, blue, green, purple and black. The main part of the coat of arms is the shield on which there are designs or charges. Underneath is a scroll with a motto, and on top a helmet. Draped over the helmet and falling down gracefully on either side is the mantling, which sometimes looks like stylized foliage and sometimes like swathes of ribbon or fabric. On top of the helmet is the wreath, and on top of that the crest. The helmet and the crest usually face the dexter or right side (from the wearer's point of view). If they face the other way it presumably indicates that the owner is either in retreat, or he is left-handed.

The example here is entirely fictitious. It has been painted with coloured inks and water colours, and then shaded with coloured pencils.

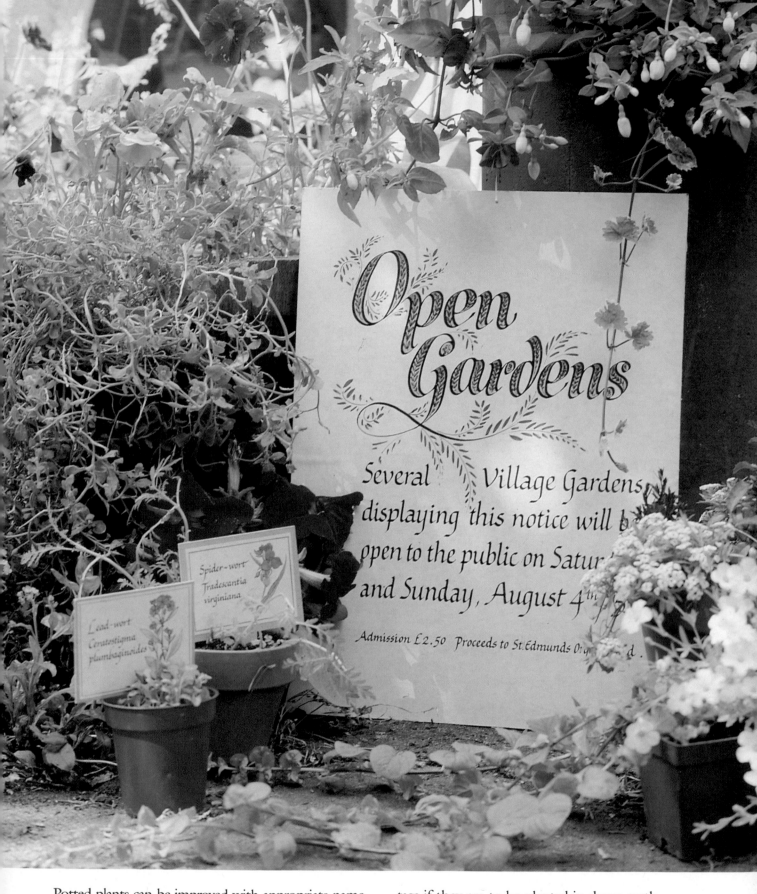

Potted plants can be improved with appropriate name tags. These may be given a coat of varnish and covered with tacky clear film as a protection against moisture. Wooden lollipop sticks can be used to support name tags if they are to be planted in damp earth.

Similar labels, incidentally, can be used to identify different sorts of sandwich at the Parish Garden Party.

Mr. and Mrs. G. Roland Smith

request with pleasure the company of

at the Wedding of their daughter
Hannah Lara
to
Mr. Nicolas Alan Shugar
at the Church of St. Martin of Tours, Chelsfield,
at 2 p.m. on Saturday, 3rd of October, 1987,
and afterwards at
Cannock School, Chelsfield.

R.S.V.P.
Melilot, Well Hill Lane
Chelsfield Orpington
Kent BR6 7QJ

Calligraphic script, even when used formally, looks somehow more personal than printed type-matter. No two pieces of pen script are ever identical though they may sometimes seem so. If the struggling scribe were actually to achieve absolute perfection then he or she would be on a level with computer typesetting. Infallibility may be very reassuring, but it is not much fun.

This wedding invitation has been written in a kind of formal Italic and then printed lithographically. One advantage is that the name of each recipient can then be written in using precisely the same style.

Notice the monogram at the top. It was a happy coincidence that the two initials could be made to share the same vertical stem. The resulting 'logo' was also used on place cards, service sheets, and in icing on the cake.

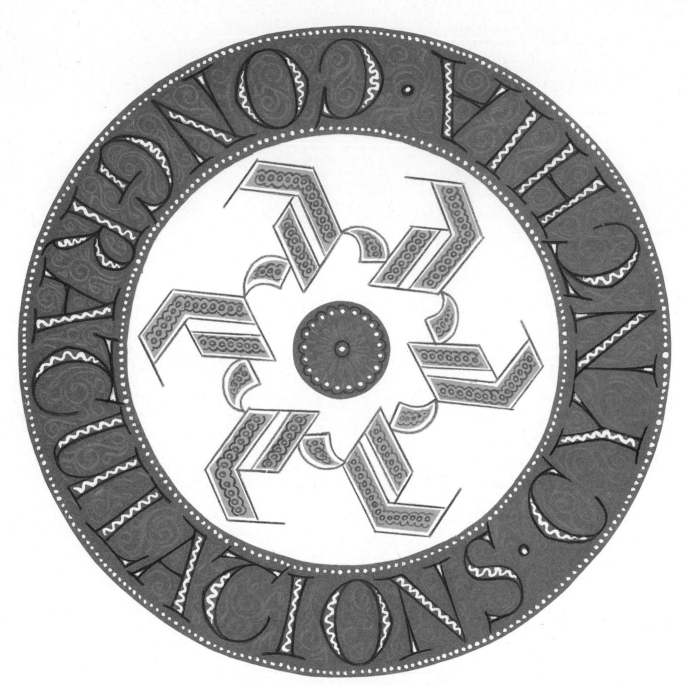

Cake icing, these days, has become a highly sophisticated business. There seems to be no limit to the intricacies which can be achieved by serious exponents of the craft. Even the less ambitious derive considerable pleasure from designing cakes for birthdays, christenings, weddings, Christmas, Easter, and other special occasions.

Most lettering styles resulting from the use of the chisel-shaped nib do not translate readily from quill to piping nozzle. The familiar thicks and thins do not arise automatically. Sugarcraft letters are more likely to be found among the drawn letters rather than the pen letters. The bulkier styles, like the Lombardic, can be achieved by piping the outlines, filling between the lines, and adding fine decoration on top.

The Versal alphabet is also very useful. It is rather important to have a complete plan of action, especially when lettering within precise limits, as, for example, round a circle. Illustrated here is a circular cake design made with cut paper. The lettering and the surface decoration have been drawn with coloured pencils. Versals have been used round the outside: the design within is an arrangement of six Gothic capital 'C's. For another useful alphabet in this connection see page 23 where there is also a set of numerals which will be particularly useful enlarged for a child's birthday cake.

A study of decorative initials in medieval manuscripts should reveal a wealth of ornament, especially lattice work, which can be adapted for sugarcraft exhibits.

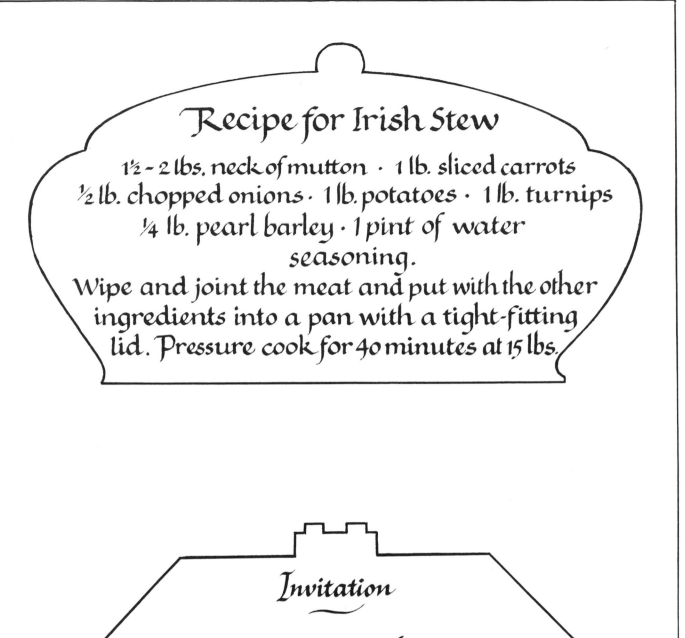

Recipe for Irish Stew

1½ - 2 lbs. neck of mutton · 1 lb. sliced carrots
½ lb. chopped onions · 1 lb. potatoes · 1 lb. turnips
¼ lb. pearl barley · 1 pint of water
seasoning.
Wipe and joint the meat and put with the other
ingredients into a pan with a tight-fitting
lid. Pressure cook for 40 minutes at 15 lbs.

Invitation

Peter and Sylvia
are invited to
A House Warming Party
at The Haven, Oak Hill, Tandridge. TG1 4PL
on Friday, 9th. March at 7.30 pm.
R.S.V.P. Henry and Sue.

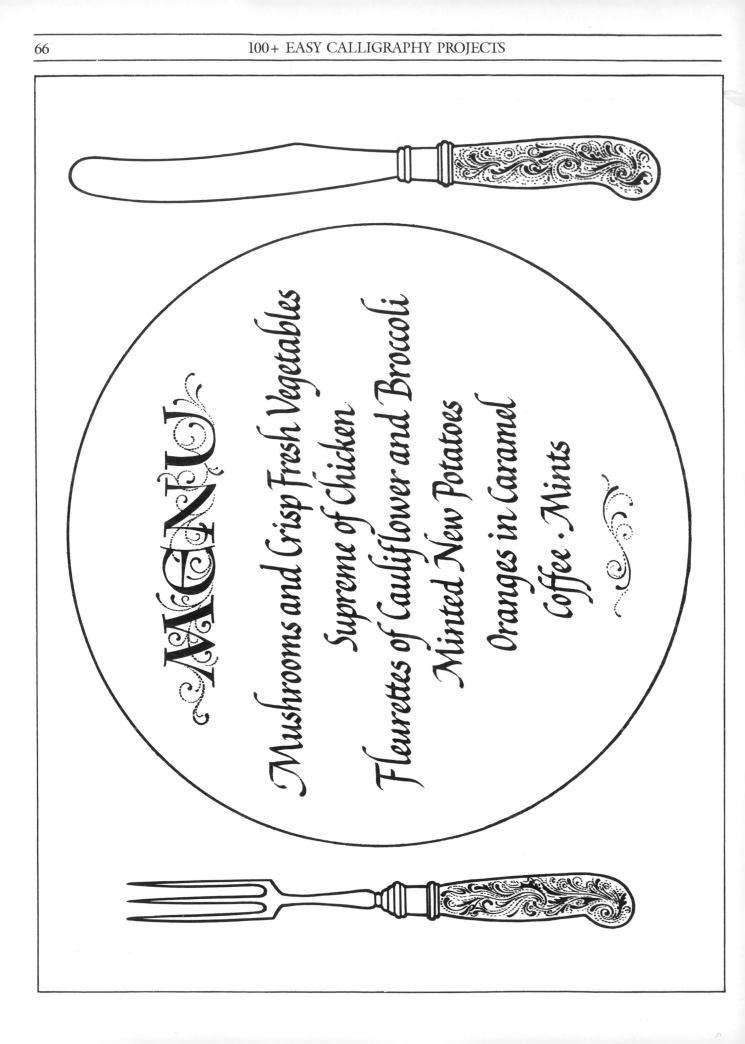

MENU

Mushrooms and Crisp Fresh Vegetables

Supreme of Chicken

Fleurettes of Cauliflower and Broccoli

Minted New Potatoes

Oranges in Caramel

Coffee · Mints

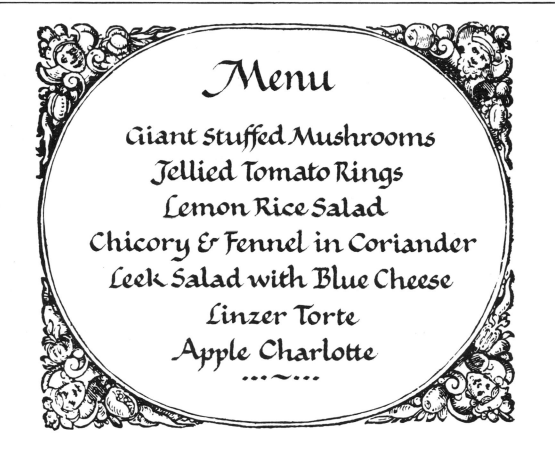

Menu

Giant Stuffed Mushrooms
Jellied Tomato Rings
Lemon Rice Salad
Chicory & Fennel in Coriander
Leek Salad with Blue Cheese
Linzer Torte
Apple Charlotte
···~···

PAPER-CUTS

Paper cutting is an ancient craft which relates particularly well to some calligraphic styles, especially Gothic. Designs cut from paper are found in the folk art traditions of America and several European countries such as Switzerland and Poland. In the Orient, paper cut figures were used in shadow theatres, and the craft has also been used extensively as the basis for stencil work. Paper cuts have been used to adorn dowry chests, furniture, family albums and various household utensils.

Since the paper is usually folded before cutting, designs tend to be mostly symmetrical and the technique of cutting with knife, leather punch, or scissors, produces clean decisive lines with a special affinity to letter forms.

The design on page 69 for a document box makes use of paper which has only been folded once. Black paper of medium weight was used and the pattern was cut with a scalpel. The tricky part was getting the design mounted: adhesive was applied to the back with a glue stick (such as a Prittstick) and the paper was gently pressed into position under a sheet of tracing paper.

The lettering is fairly standard Gothic with some rather spiky capitals. Notice that the text is justified right and left (the lines are all the same length.) This helps to integrate words and illustration.

The circular design on page 69 is based on a paper cut with eight identical sectors: the paper was folded double three times. The resulting wheel provides a foundation for a circle of Italic writing, that is if you can find something relevant to say which happens to be just the right length. It might be easier to start with the inscription and then make a paper cut to fit. Designs such as this, if mounted on cork tiles or plywood, make good table mats, but they need to be protected with several coats of tough varnish.

The Property of Dimitri Rainbird, this box
contains Documents concerning the History of
the Rainbird Family and their ancient home
at Featherstone in the County of Wiltshire.

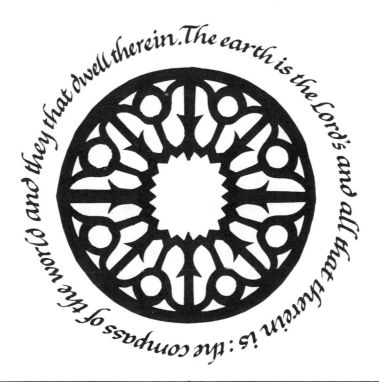

The earth is the Lord's and all that therein is: the compass of the world and they that dwell therein.

A SIMPLE INSCRIPTION

Sometimes words and pictures come together almost of their own accord. In this case the picture came to light first. It is an engraving from about 1560 of an artificial hand, typical of those designed by Ambroise Pare for men who had been injured in battle. The thought that soldiers might have been engaged in a little quiet calligraphy at home prompted the well-known motto. The result is an inscription which might be suitable as a bookmark, or a card to accompany a gift of stationery.

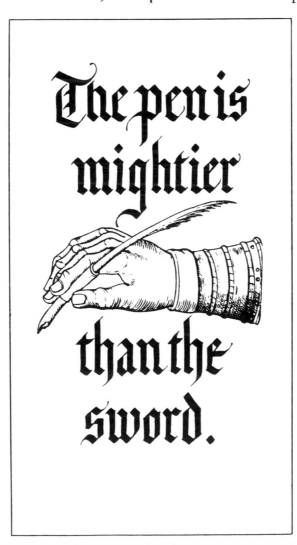

BASIC STRAPWORK

There is something magical about ribbons tied into impossible knots. Calligraphers may wish not to delve too deeply into the mathematics. Some early Celtic manuscripts have such a wealth of intricate geometry it is difficult to know where to start and where to stop. Even without reading what they say, and without studying all the weird creatures that inhabit the latticework, it is easy to see that they deal in ancient mysteries. Three of the easier paths are shown here — two based on a regular five-sided figure, and one based on a seven-sided figure. The interesting thing about odd numbers is that they tend to produce pathways that, despite all their wanderings, manage to catch up with themselves. So, if we use the strapwork actually to carry the inscription then the length of the message in relation to the size of the design becomes rather crucial. Solving problems of this sort can be immensely satisfying . . . and infuriating.

It is difficult to see much practical advantage in such virtuoso performances but they are useful in the design of emblems or badges, and can sometimes be adapted for use on bookplates, letterheadings, or certificates.

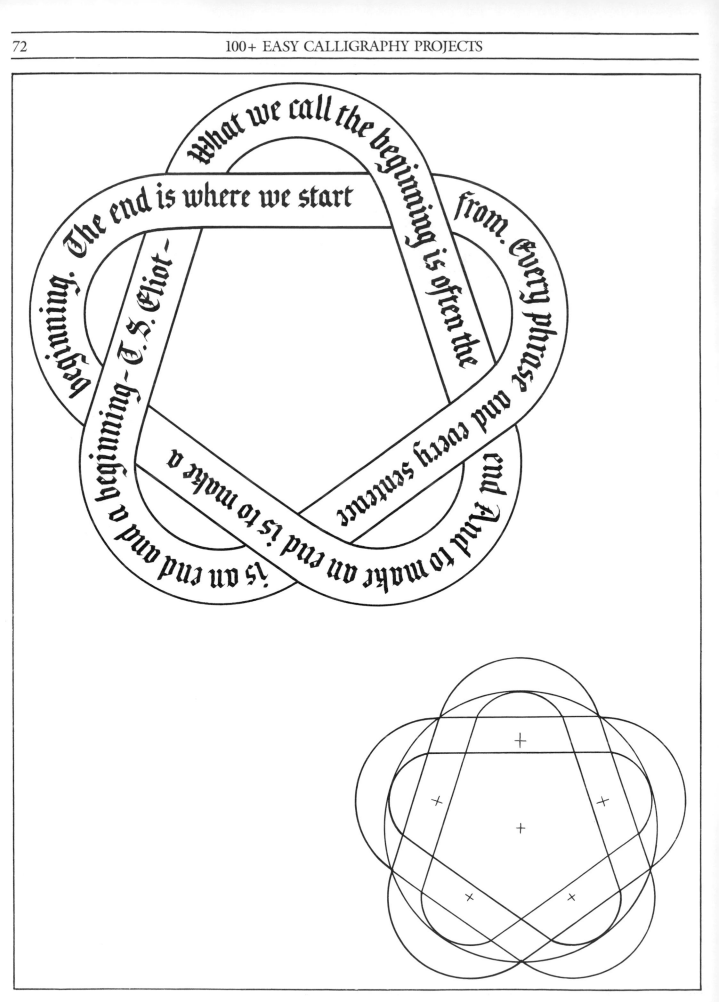

What we call the beginning is often the end And to make an end is to make a beginning. The end is where we start from. Every phrase and every sentence is an end and a beginning ~ T. S. Eliot ~

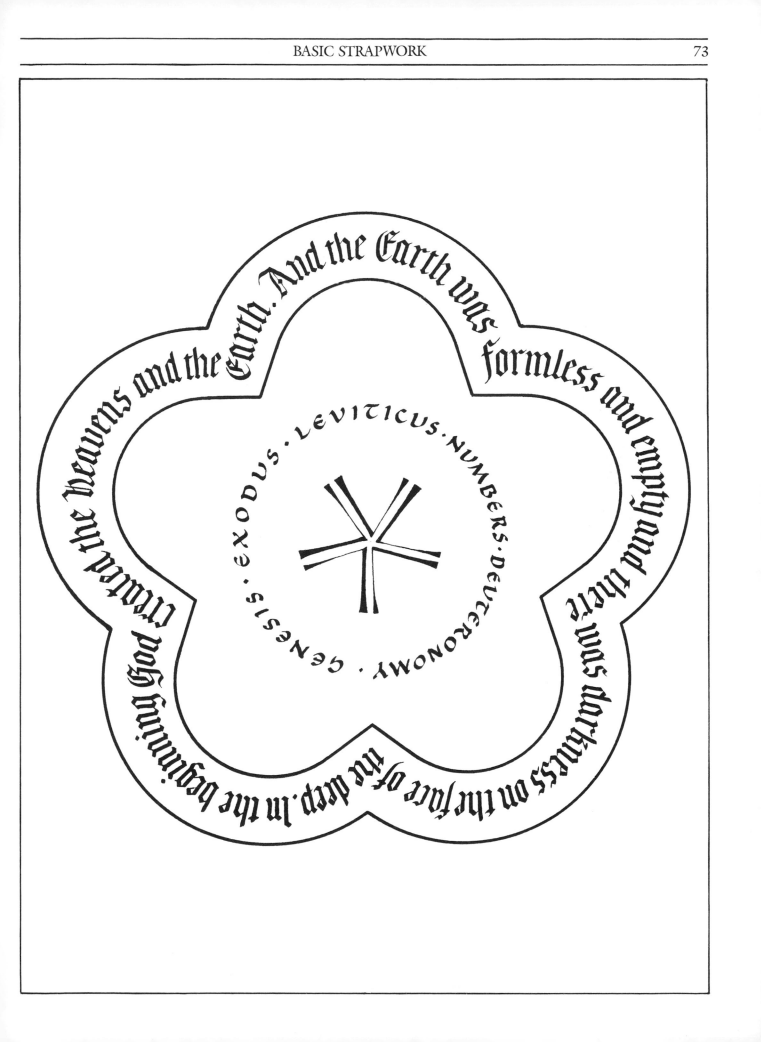

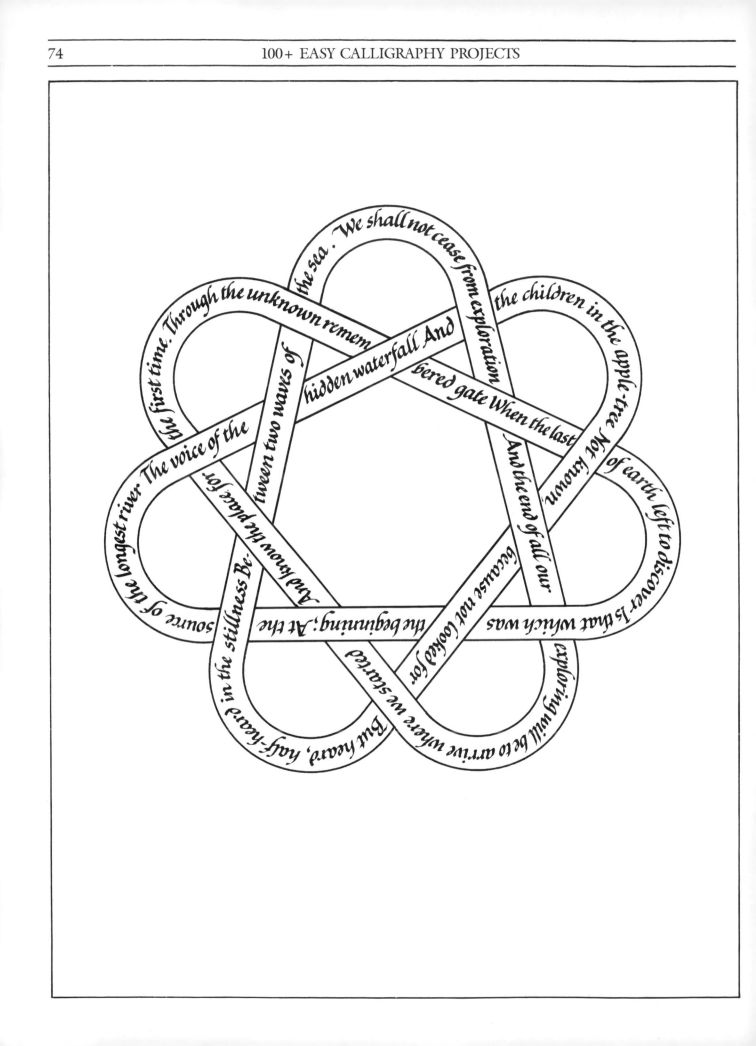

TIMELESS TEXTURES

To some extent calligraphic styles usually reflect something of the spirit of the time when they were first in common use. One notable exception is the Roman Monumental Capital, first developed to be incised in stone commemorating the exploits of the Roman Legions, but still widely used today as a newspaper type. Generally, though, pen written scripts hark back to medieval times, and traditional scripts conjure up historical pictures. A powerful ingredient of any piece of lettering, however, is its surface quality — its texture; rough or smooth, coarse or fine, parched or lush, light or heavy, and so on — and this owes nothing to any particular age. When designing posters, leaflets or book covers it is important to bear the texture in mind. It may be the first thing that the reader notices.

A piece of coarse canvas was first covered with black gouache and pressed down on white paper while the paint was still wet. When dry, the paper was cut into the shapes of the sans serif letters which were stuck down one at a time. The Gothic letters were drawn with a pointed nib.

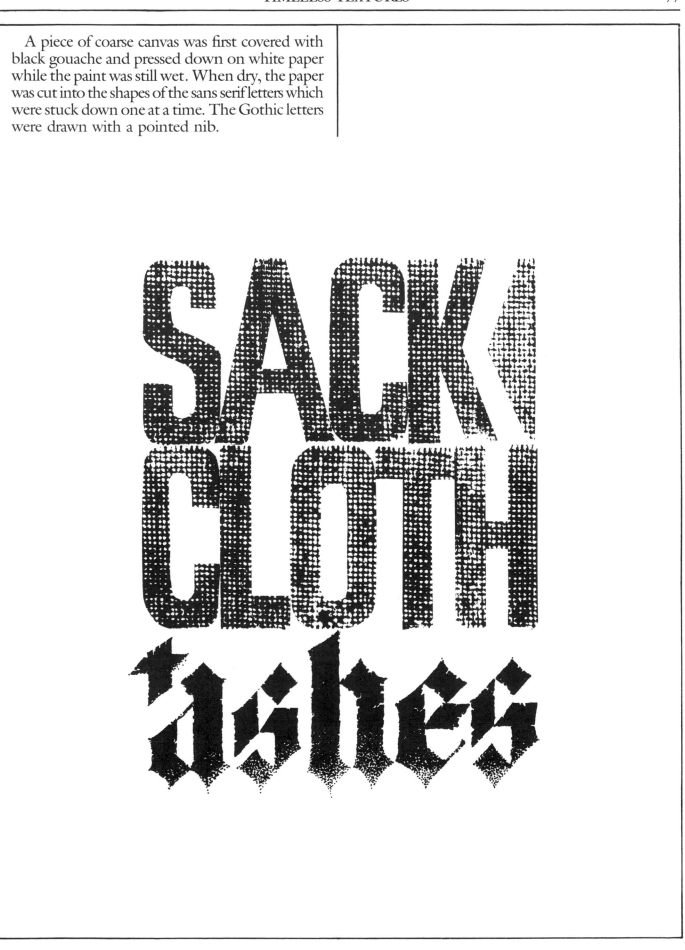

The larger letters are built up with spots drawn with black marker pen and arranged along pencil lines which were afterwards rubbed out. Technical pens will produce regular spots of a particular size. The smaller Versals were drawn with a pointed nib.

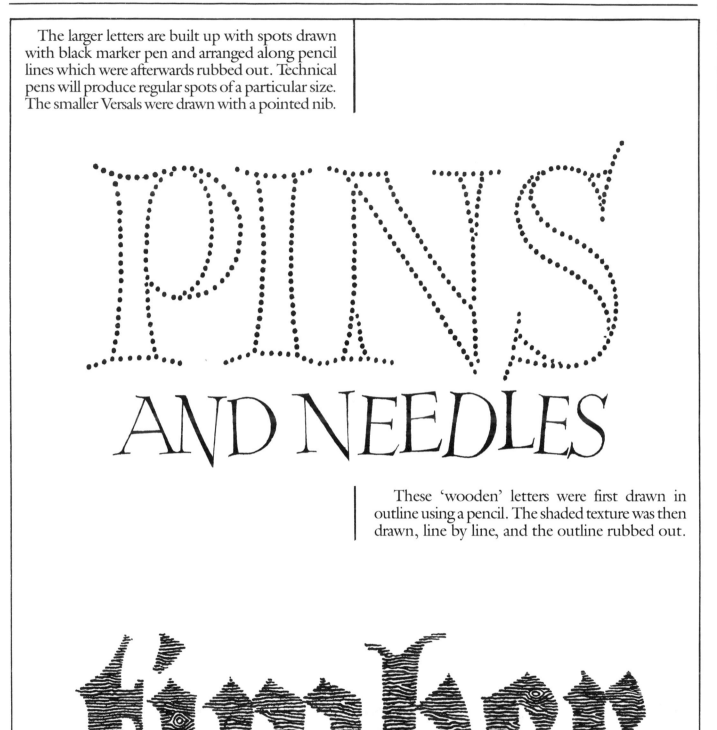

These 'wooden' letters were first drawn in outline using a pencil. The shaded texture was then drawn, line by line, and the outline rubbed out.

This was written with a five-pointed nib used for ruling music scores. The feather was drawn with a conventional pointed nib, and the small lettering with a chisel-shaped nib (No. 5).

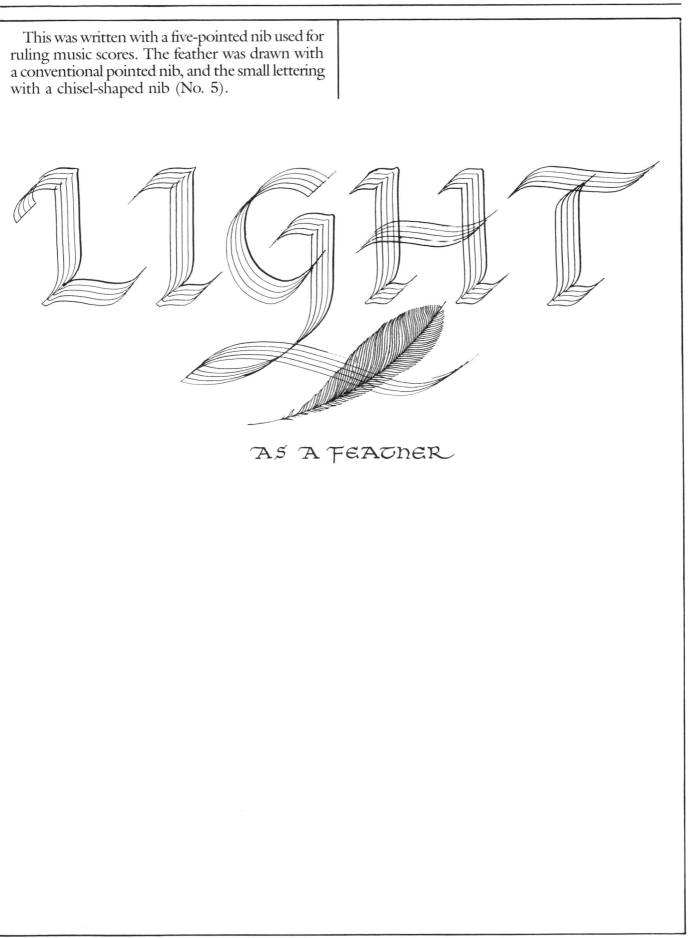

WORD SEARCH PUZZLE

The rectangle conceals a number of calligraphic terms and words connected with writing generally. They are arranged horizontally, vertically and diagonally. The creation of such a puzzle provides useful practice in writing capitals, and the border, though uncomplicated, needs a steady hand and a sense of rhythm.

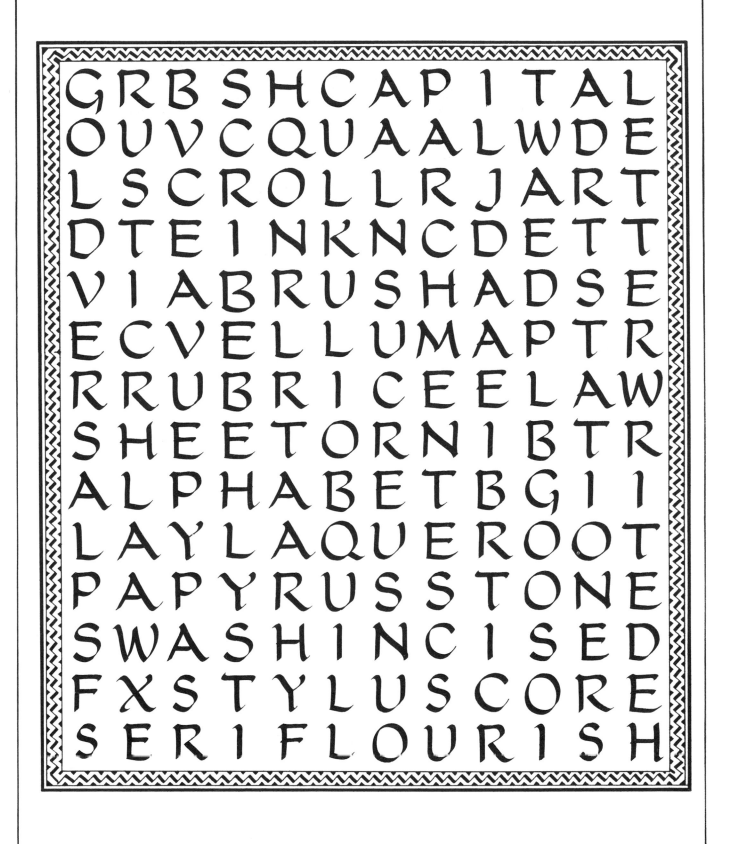

```
G R B S H C A P I T A L
O U V C Q U A A L W D E
L S C R O L L R J A R T
D T E I N K N C D E T T
V I A B R U S H A D S E
E C V E L L U M A P T R
R R U B R I C E E L A W
S H E E T O R N I B T R
A L P H A B E T B G I I
L A Y L A Q U E R O O T
P A P Y R U S S T O N E
S W A S H I N C I S E D
F X S T Y L U S C O R E
S E R I F L O U R I S H
```

MONASTIC RACE GAME

The brothers are on their way to the monastery. Who will arrive first? This is a game for two or more players: each has a counter or token (the monks themselves could be traced, cut out and made to stand up on little blocks of wood). They take turns to move according to a throw of dice.

Apart from its value as a game, the project offers considerable scope for exercising a variety of calligraphic skills — and some literary ones when it comes to inventing instructions along the route.

Use a strong black outline for the main structure with plenty of bright colour for the steps along the way and for the 'illuminated' bits. If drawn directly on a smooth watercolour board any further need for mounting can be avoided. The finished work may be protected with clear adhesive film or varnish.

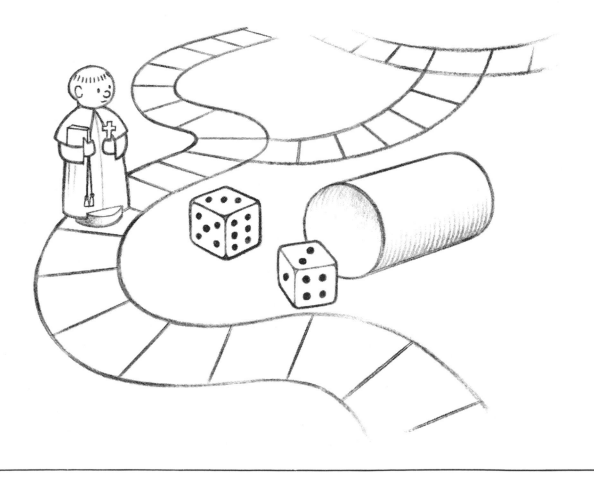

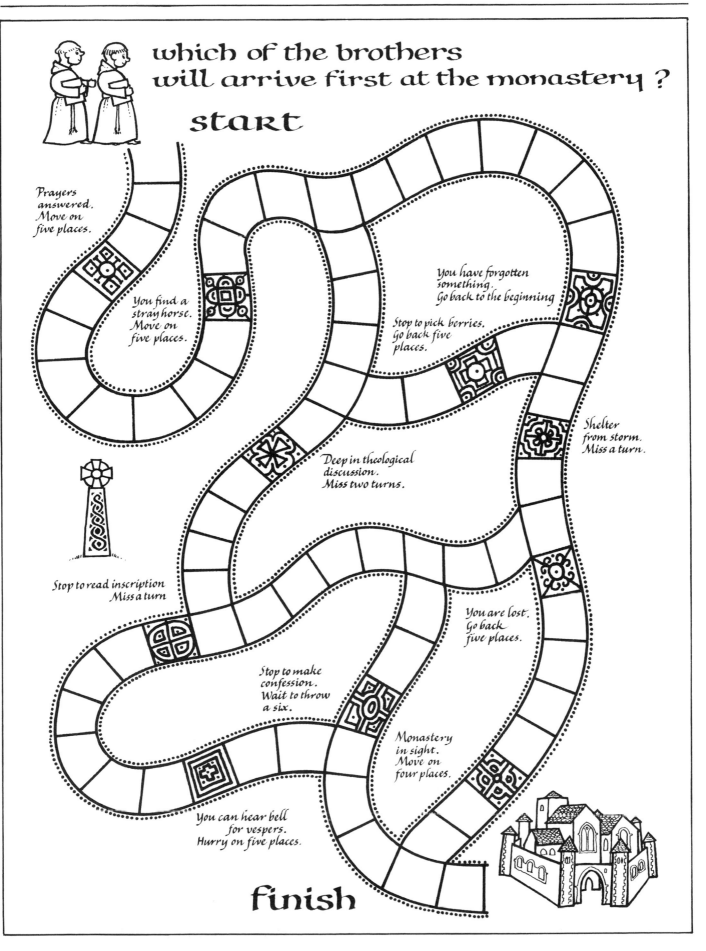

which of the brothers
will arrive first at the monastery ?

start

Prayers answered. Move on five places.

You find a stray horse. Move on five places.

You have forgotten something. Go back to the beginning

Stop to pick berries. Go back five places.

Shelter from storm. Miss a turn.

Deep in theological discussion. Miss two turns.

Stop to read inscription Miss a turn

You are lost. Go back five places.

Stop to make confession. Wait to throw a six.

Monastery in sight. Move on four places.

You can hear bell for vespers. Hurry on five places.

finish

MORE BORDERS

Inventing borders is not only a decorative occupation; it provides practice in the sort of pen strokes used in writing. If a particular letter or part of a letter is proving difficult, devise a border which includes the troublesome feature. Exercises of this kind can be used as bookmarks, memo pad covers, covers for photo albums, and other small items.

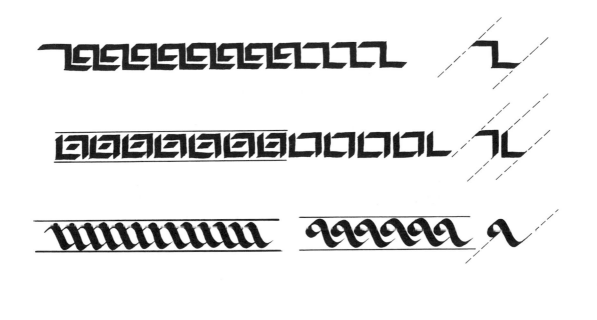

CALENDARS

Publishing a limited edition of your own calendar is perfectly feasible using a photo-copier. It also provides useful practice if you are not too hot on numerals. Three possible layouts are shown here involving different writing styles and space for some suitably inspiring quotation. An interesting high quality paper could be used. The finished calendar could be spiral or 'comb' bound — a service now offered by many copy shops who will be willing to bind a modest quantity. An original calendar makes a nice gift for circulation among privileged friends, or it could be designed to feature some particular charitable organization and sold as a fund-raiser.

April

Sunday · Monday · Tuesday · Wednesday · Thursday · Friday · Saturday

Sunday	Monday	Tuesday	Wednesday	Thursday	Friday	Saturday
					1	2
3	4	5	6	7	8	9
10	11	12	13	14	15	16
17	18	19	20	21	22	23
24	25	26	27	28	29	30

February

Mon		6	13	20	27
Tue		7	14	21	28
Wed	1	8	15	22	29
Thur	2	9	16	23	
Fri	3	10	17	24	
Sat	4	11	18	25	
Sun	5	12	19	26	

June

Sunday	18
Monday	19
Tuesday	20
Wednesday	21
1 Thursday	22
2 Friday	23
3 Saturday	24
4 Sunday	25
5 Monday	26
6 Tuesday	27
7 Wednesday	28
8 Thursday	29
9 Friday	30
10 Saturday	
11 Sunday	
12 Monday	
13 Tuesday	
14 Wednesday	
15 Thursday	
16 Friday	
17 Saturday	

When thou cuttest down thine harvest in thy field, and hast forgot a sheaf in the field, thou shalt not go again to fetch it : it shall be for the stranger, for the fatherless, and for the widow : that the Lord thy God may bless thee in all the work of thine hands.

When thou beatest thine olive tree, thou shalt not go over the boughs again : it shall be for the stranger, for the fatherless, and for the widow.

Deuteronomy.

CALLIGRAPHIC PLAYING CARDS

A complete pack of Slender Versals is included here. This elegant drawn-letter alphabet is a very useful one requiring considerable patience. They have been shown as playing cards with number values because in this form they could be used for a variety of spelling games. A tough pliable card such as Bristol Board is recommended, and since they must withstand much handling a covering of clear adhesive film would be a good idea.

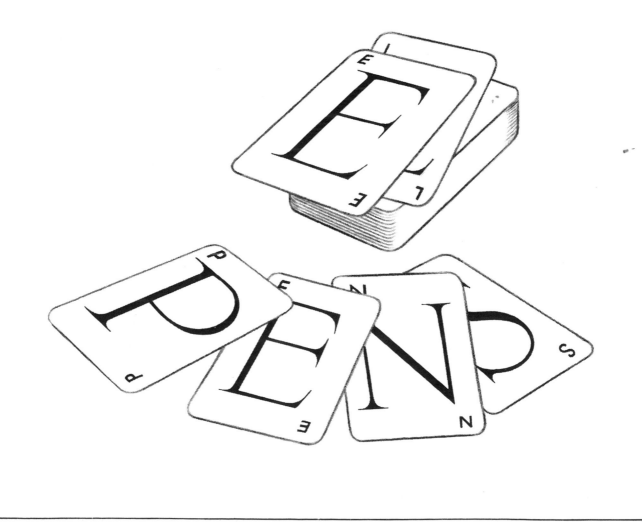

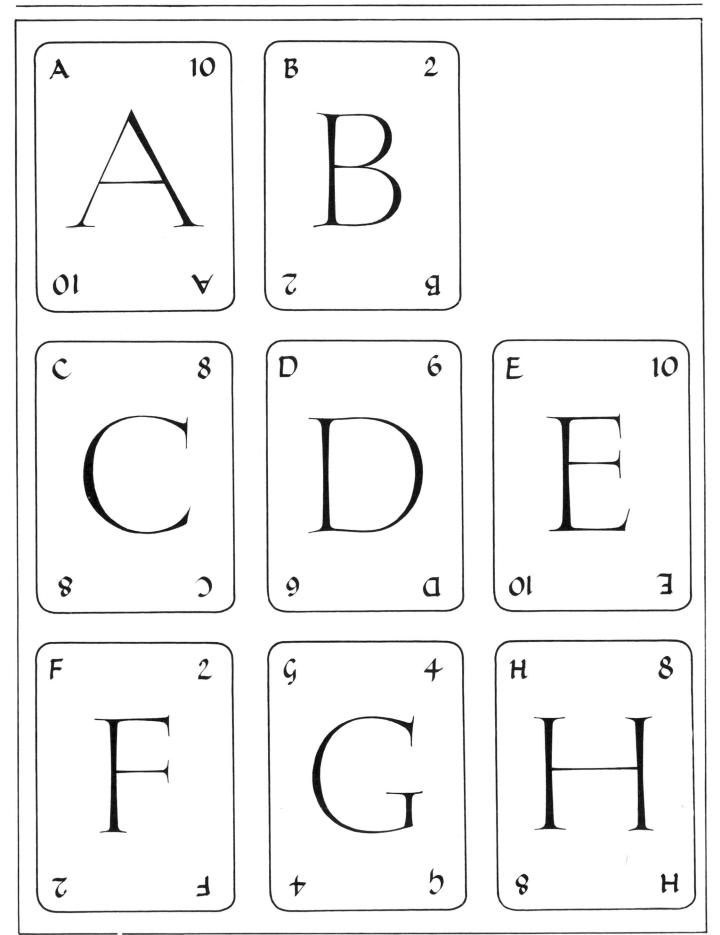

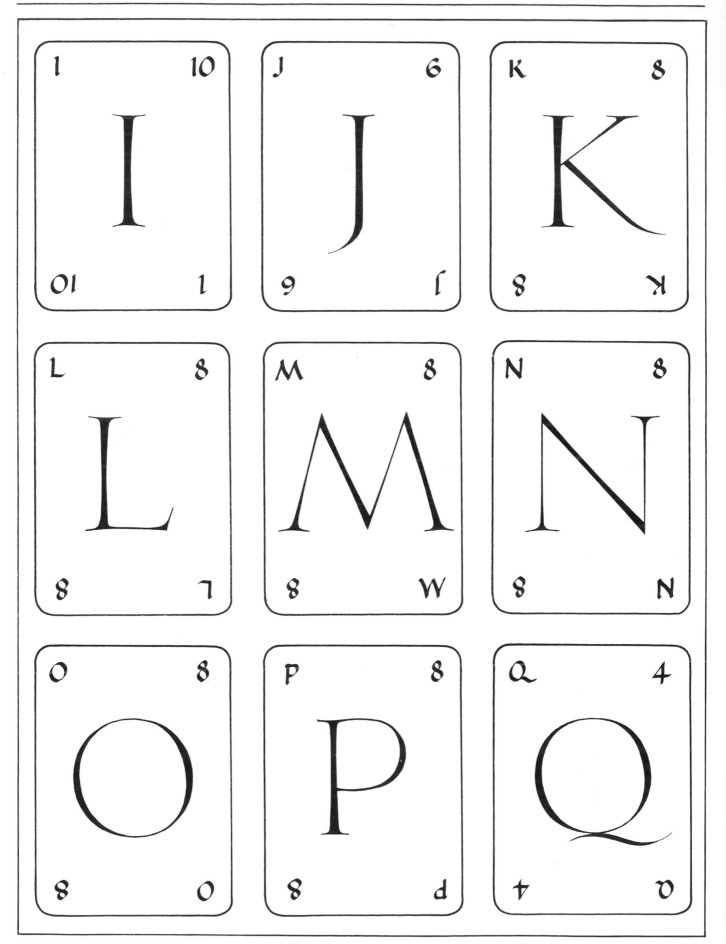

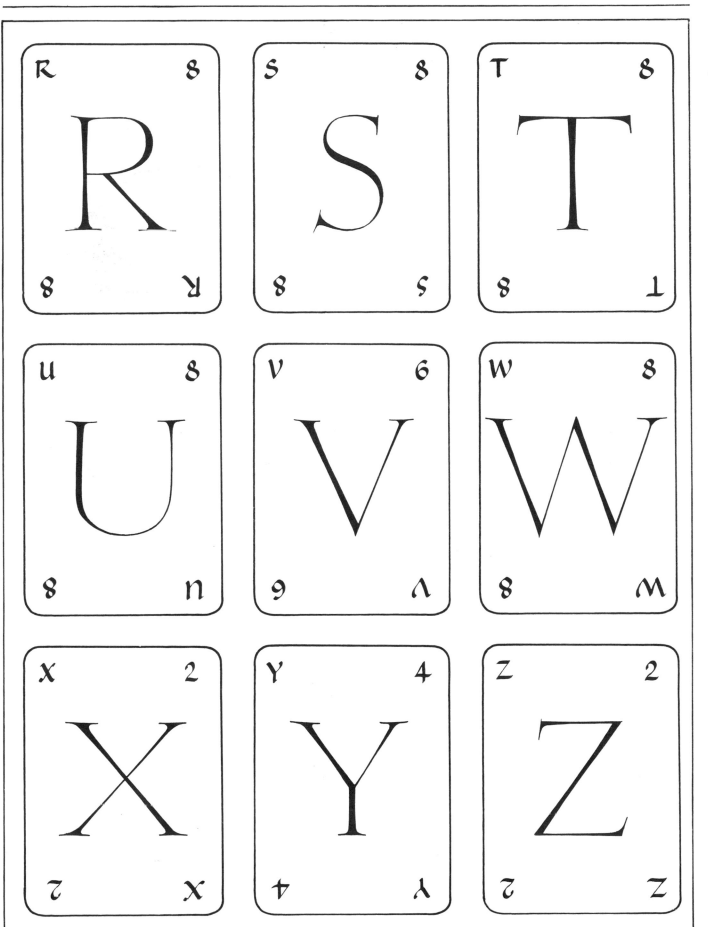

LEARNING LETTERS

Learning how to write letters beautifully may be just as difficult as it was to learn how to read them. The designs on this page are typical of the sort of 'alphabet jig saws' which can be used by young children learning to read.

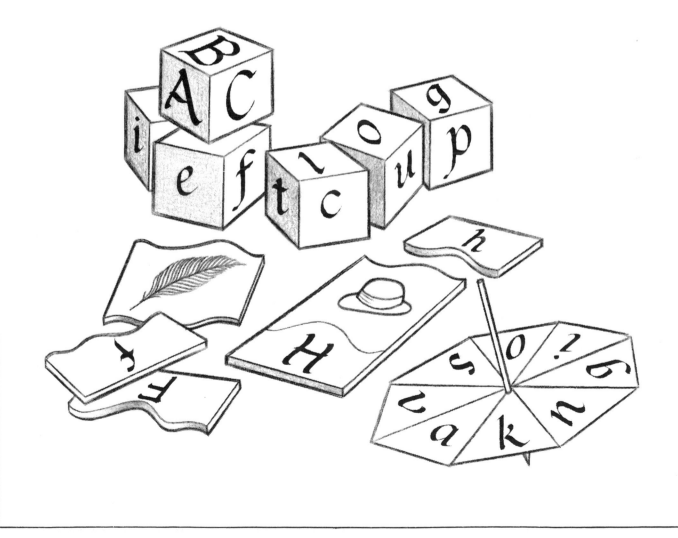

Ss snail

Dd duck

Ff fish

Bb bird

Cc cat

Tt tortoise

A VARIETY OF TECHNIQUES

There now follows an alphabet of large capitals which may be regarded as the 'Special Effects' Department. They demonstrate various methods for achieving textures and patterns. Although complete words could obviously be made, these letters are of a kind that normally appear singly.

Used sparingly, in conjunction with passages of straightforward script, they perform a function similar to the illuminated initials that enrich many medieval manuscripts. When ideas are slow in coming it is often helpful to experiment freely with colours and materials.

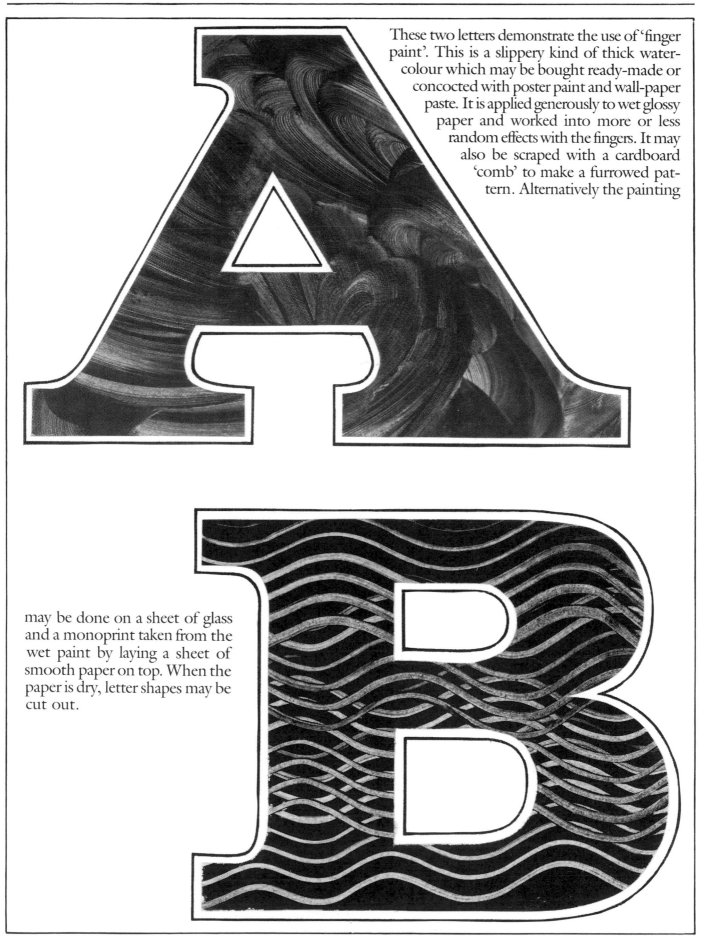

These two letters demonstrate the use of 'finger paint'. This is a slippery kind of thick watercolour which may be bought ready-made or concocted with poster paint and wall-paper paste. It is applied generously to wet glossy paper and worked into more or less random effects with the fingers. It may also be scraped with a cardboard 'comb' to make a furrowed pattern. Alternatively the painting

may be done on a sheet of glass and a monoprint taken from the wet paint by laying a sheet of smooth paper on top. When the paper is dry, letter shapes may be cut out.

Here a rubbing has been made from a piece of embossed wallpaper. Several parts of the design have then been cut out and arranged within the outline of a letter.

This letter has been filled with type matter, not for the sake of what it says, but because of its decorative texture.

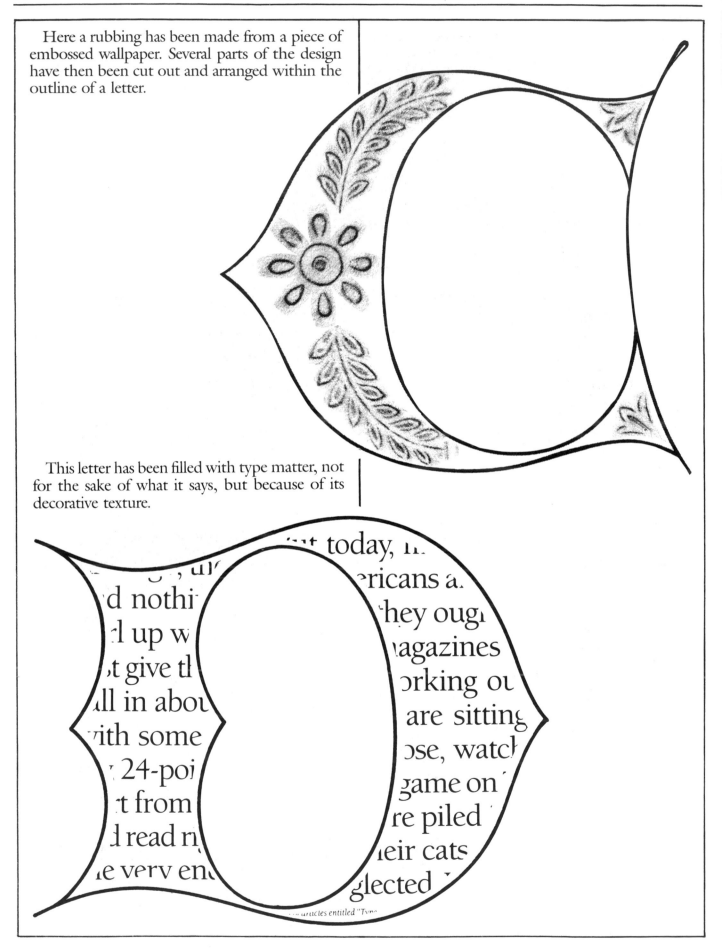

A mosaic of cut paper. The outer border has been drawn with a chisel-shaped lettering nib, but the main design is built up with dozens of little irregular squarish tesserae. This is easier than it looks. If tacky labels are cut into strips and the backing removed then small squares can be snipped off and pressed down fairly quickly. The 'counterchange' principle has been used — dark on light, and light on dark.

Wax crayons have been used here. On a separate sheet of paper, white crayon was applied, then a covering of black. (Pale colours and dark colours could be used for a less stark effect.) The design was made by scraping through the black to reveal the white, first using an old lettering nib to form a repeating pattern, and then using the blunt point of a penknife to make a picture. Finally, the letter shapes were cut out and mounted within an outline.

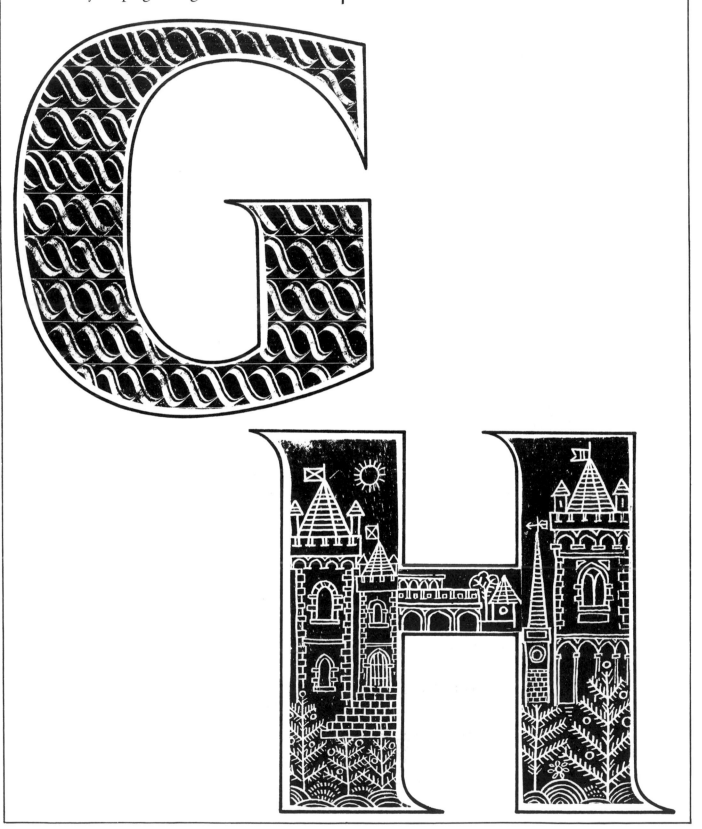

More crayon rubbings, first from an enamelled brooch (consider other likely articles — keys, coins, etc.) and then from an assortment of leaves — use those with a pronounced rib structure. The leaf rubbings were cut out, one at a time, and stuck down within the outline of the letter. Combined with colour and the use of tinted papers this would make a very suitable initial for use with something autumnal.

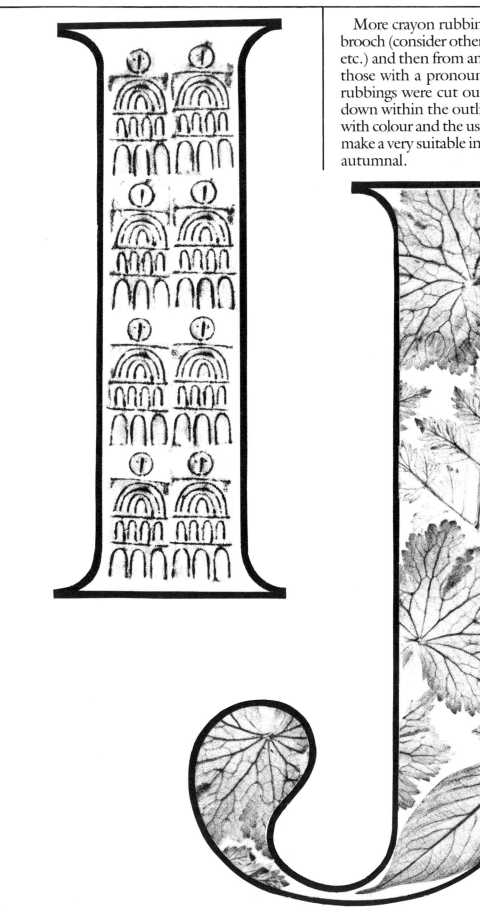

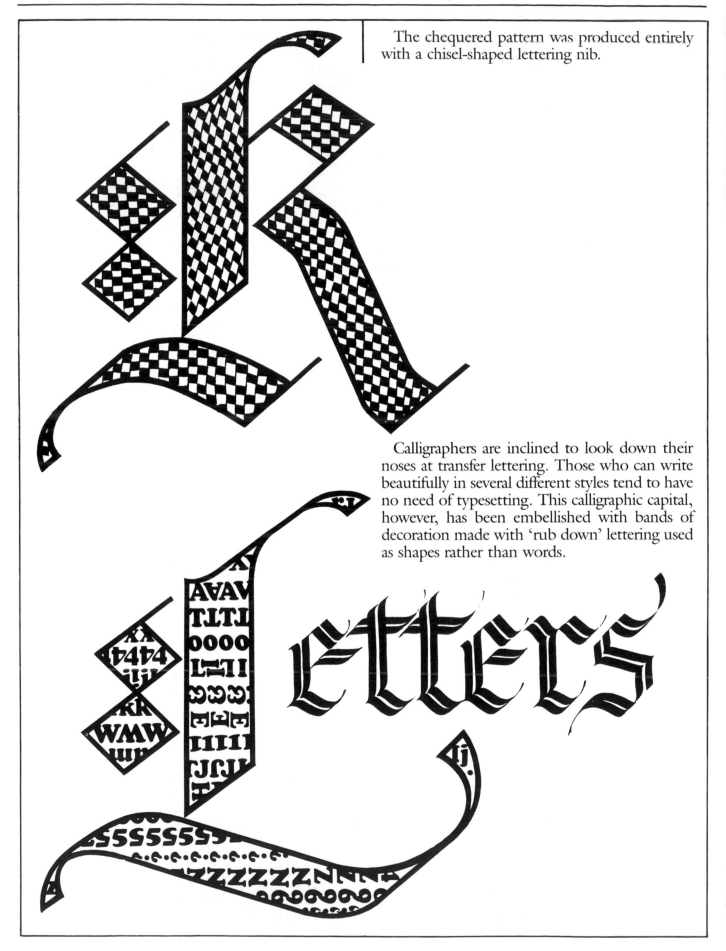

The chequered pattern was produced entirely with a chisel-shaped lettering nib.

Calligraphers are inclined to look down their noses at transfer lettering. Those who can write beautifully in several different styles tend to have no need of typesetting. This calligraphic capital, however, has been embellished with bands of decoration made with 'rub down' lettering used as shapes rather than words.

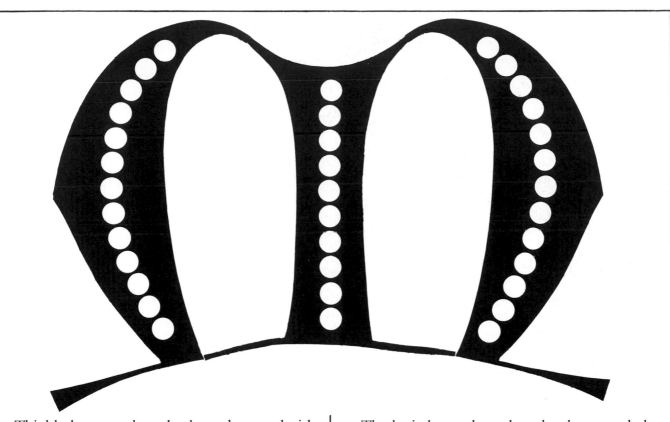

This black cut-out letter has been decorated with lines of white circles. The circles are made with a hole punch. Holes were punched in tacky white labels to make a plentiful supply of self adhesive 'confetti'.

The basic letter shape here has been made by applying paint with a sponge through a stencil. The decoration is in the form of shapes cut from folded paper.

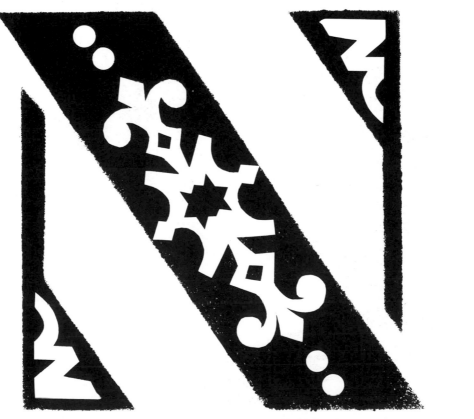

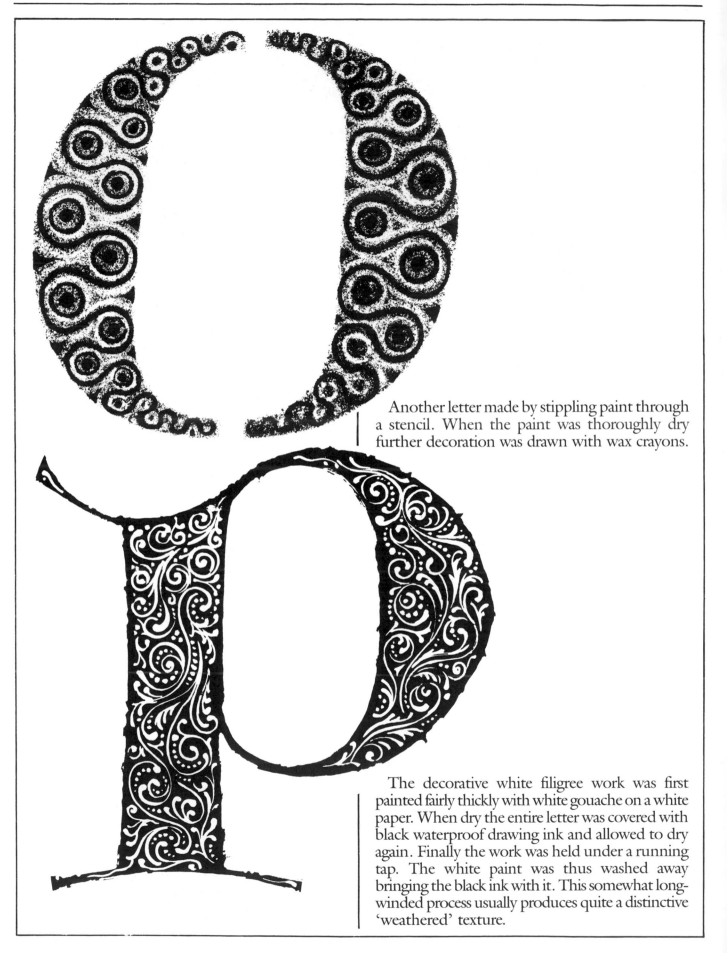

Another letter made by stippling paint through a stencil. When the paint was thoroughly dry further decoration was drawn with wax crayons.

The decorative white filigree work was first painted fairly thickly with white gouache on a white paper. When dry the entire letter was covered with black waterproof drawing ink and allowed to dry again. Finally the work was held under a running tap. The white paint was thus washed away bringing the black ink with it. This somewhat long-winded process usually produces quite a distinctive 'weathered' texture.

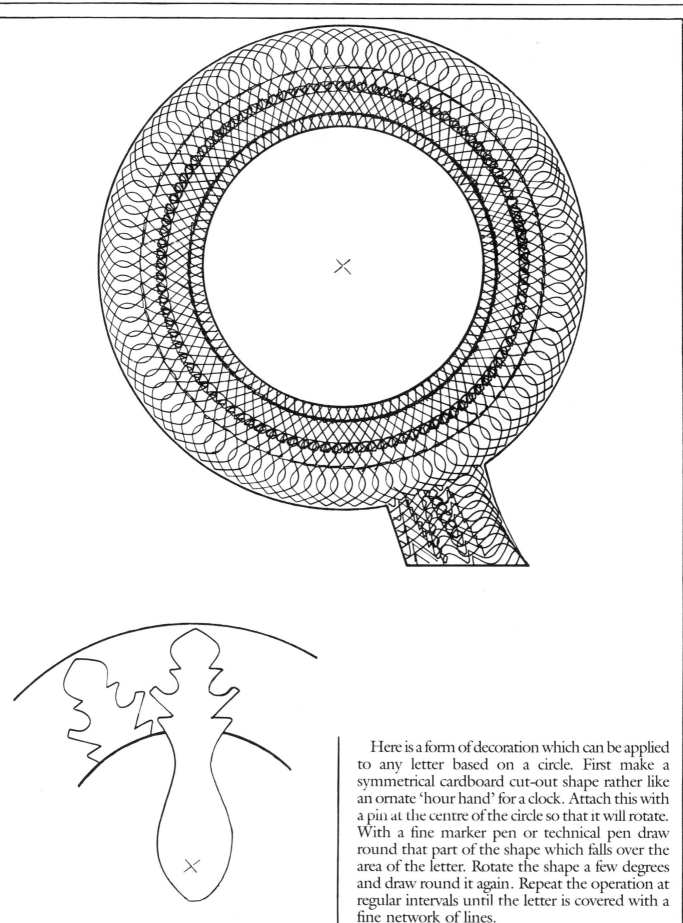

Here is a form of decoration which can be applied to any letter based on a circle. First make a symmetrical cardboard cut-out shape rather like an ornate 'hour hand' for a clock. Attach this with a pin at the centre of the circle so that it will rotate. With a fine marker pen or technical pen draw round that part of the shape which falls over the area of the letter. Rotate the shape a few degrees and draw round it again. Repeat the operation at regular intervals until the letter is covered with a fine network of lines.

Photographs may be used to create a montage within the outlines of the letters. Use letters which are bold and straightforward giving plenty of area for treatment. As each piece of photograph is mounted make a tracing of its shape so that this can be transferred to the next piece; thus the photographs will neatly butt up against each other.

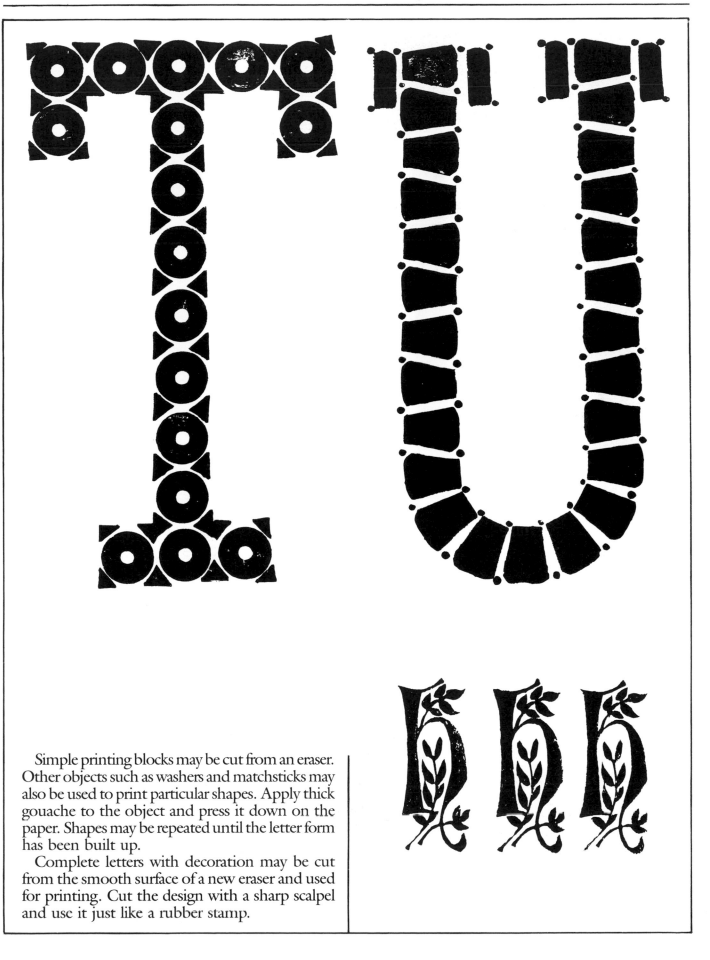

Simple printing blocks may be cut from an eraser. Other objects such as washers and matchsticks may also be used to print particular shapes. Apply thick gouache to the object and press it down on the paper. Shapes may be repeated until the letter form has been built up.

Complete letters with decoration may be cut from the smooth surface of a new eraser and used for printing. Cut the design with a sharp scalpel and use it just like a rubber stamp.

Illustrations can be incorporated within the shape of the letter itself if the design is such that it forms a frame or cartouche. The illustrations in this example are old wood engravings.

Drawings consisting of closely knit textures can be made to conform to the shape of a letter. This one is made of winter trees. Other possibilities are ferns, frost, pebbles, grasses or seaweed.

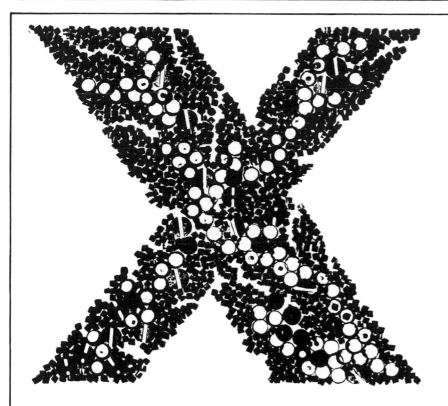

The texture here has been built up with hundreds of prints from a screw-head, a piece of tubing, and a matchstick.

Another piece of calligraphic topiary. This sort of drawing requires patience rather more than draughtsmanship.

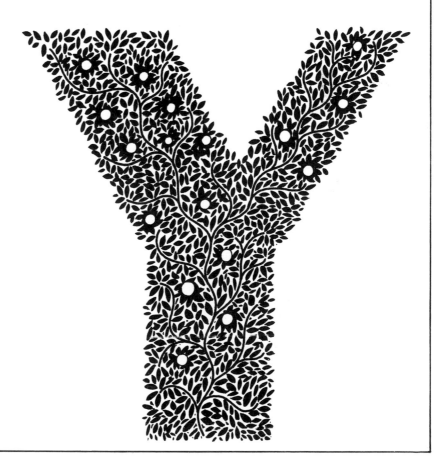

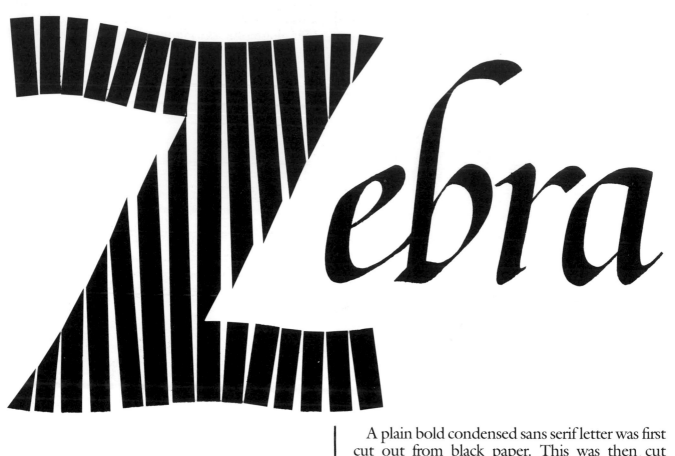

A plain bold condensed sans serif letter was first cut out from black paper. This was then cut vertically into strips taking care to remember their sequence. These were then stuck down leaving intervals of white between.

This calligraphic medley was unpremeditated. It is typical of the kind of patchwork that might evolve on the pad where pens are tried out — perhaps with more interesting results than many a more deliberate piece. There is a lot to be said for calligraphic doodling.

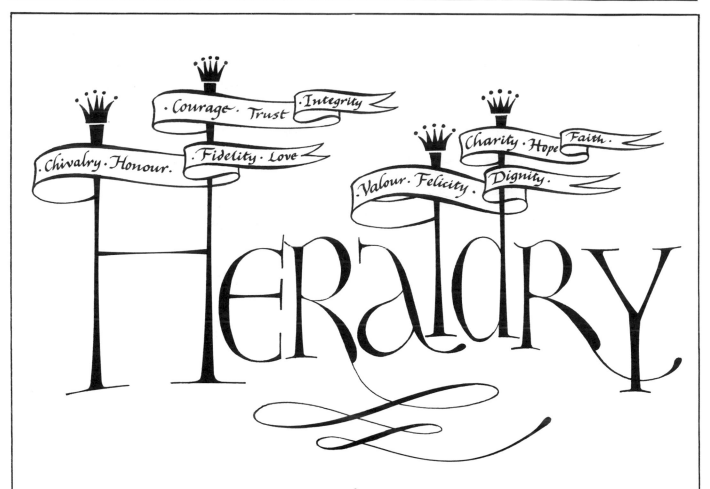

There are scarcely any straight lines in this piece. The main Versals look almost as though they might be standing on a three-dimensional stage because there has been no attempt to make them uniform in height. The ascenders have been turned into flag poles from which banners fly to carry the rest of the inscription. It is the kind of notice that might be used to advertise a course or lecture.

Some might argue about whether this is an 'R' or a 'K' or perhaps just an excuse for another pattern.

Motor Maintenance · Creative Writing · Bridge
Astronomy · Weaving
Anatomy · Electronics · Elocution · Calligraphy · Horticulture · Painting
Computers
Mathematics · Sailing · Plumbing
Fabric Printing · Yoga
Heraldry
Psychology · Archaeology

Study

Languages · Pottery · Music
Sociology

Art
Machine Knitting

Bricklaying · Embroidery ·
Cookery · Wine Making · History ·
Dressmaking
Philosophy · Typewriting

A design for a Prospectus. The Gothic is so very upright and so very black that it can easily withstand the proximity of several lines of writhing Italics.

The freely written heading below is in Rustic Capitals slightly embellished.

·· MACAVITY ··

Macavity's a ginger cat, he's very tall and thin ;
You would know him if you saw him
for his eyes are sunken in.
His brow is deeply lined with thought,
his head is highly domed ;
His coat is dusty from neglect, his whiskers are uncombed.

A booklet cover. The outer border is composed entirely of two letters of the alphabet, drawn with a technical pen and linked together by the serifs.

The central motif allows space for a changing device in the middle.

St. Andrew's with St. Peter's

Fairlight

Fairlight Praise

~◆~

Another booklet cover. This was for a selection of hymns compiled for special occasions. provided that copyright permission has been first obtained, there is no difficulty these days in copying from existing sources to make smaller publications suitable for weddings, christenings, funerals, and so on.

Hidden Treasures

An Exhibition
at N. Finchley New Church

71 Gainsborough Road

N 12

Fri. 1st Nov. 6.00pm. - 9.30pm.
Sat. 2nd Nov. 9.30am. - 5.00pm.

The lettering here has been kept fairly plain and bold so that the same original can be enlarged to make a poster, or reduced to make a catalogue cover.

Shepherds abiding in the field, keeping watch over their flock by night

These drawings with short inscriptions on a religious theme were used as Christmas cards. The strong black outline, reminiscent of the leading on stained glass windows, seemed appropriate for the weight of the script. It also made it easier for a dash of colour to be quickly brushed in by hand. Coloured markers are another quick and easy way to add a personal touch to each copy.

For thus it is written by the prophet

And when he had gathered all the chief priests and scribes of the people together, he demanded of them where Christ should be born.

No room at the Inn

MELILOT·MCMLXXXIII

There went out a decree
from Caesar Augustus
that all the world
should be taxed

*

Then Joseph, being raised
from sleep, did as the angel
of the Lord had bidden him.

Even quite small items like luggage tags present a challenge and an opportunity to the calligrapher.

The framework for a so-called 'spiral' can easily be marked out with a pair of compasses because it is not a true spiral but a set of staggered semi-circles. I always prefer to work from the inside outwards so that there is a greater chance of getting everything in before running out of space. This esoteric form of writing at least produces a mystical pattern even though it may make the reader dizzy. It may be a convenient means of summarizing a year's events and might therefore make a suitable cover or title page for an Annual Report.

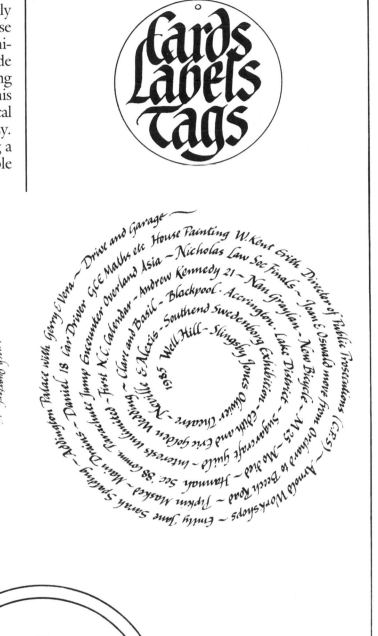

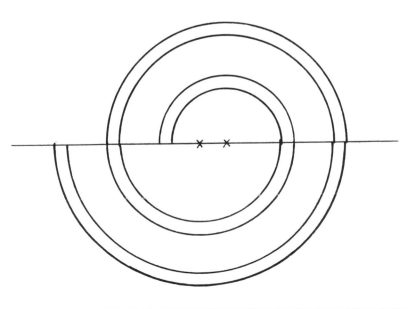

When trying to combine a lettered word with an illustration of whatever the word is saying, it is probably best to start with the letters. Then add the fewest possible extra bits of drawing. Animals with long names and long shapes are the easiest, but other creatures and objects may suggest themselves. Mounted on card they may be helpful with teaching children to spell.

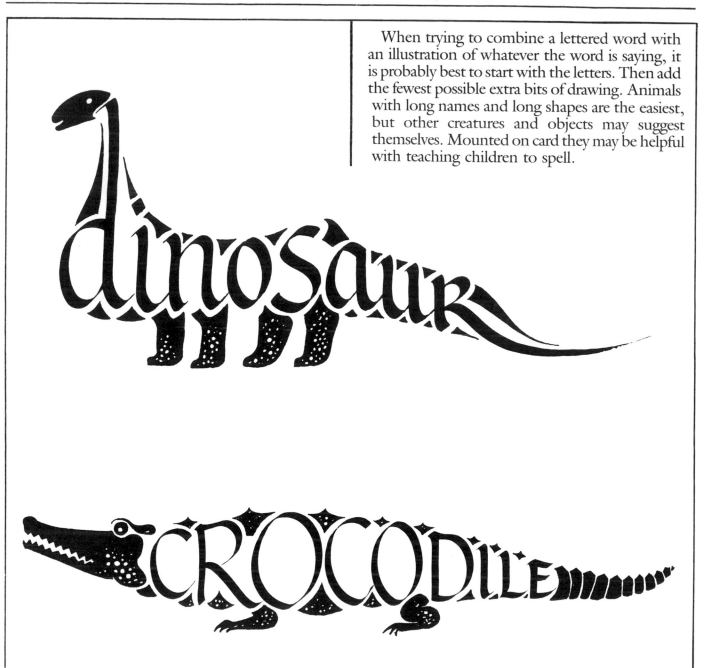

Cartouche Letters. The outline initials on the right all incorporate a decorative aperture or frame. Illustrators might be glad of the opportunity to draw a small picture to fit in the space allowed. Those without any such aspirations might prefer to use ready-made pictorial material. Old Christmas cards provide a rich source of supply. First make a tracing of the shape of the picture frame — ellipse, oval, circle, square or whatever; then transfer the shape to a relevant portion of some printed picture, and cut it out. Trace the rest of the outline of the initial itself and transfer that to paper which will carry the finished work. Stick the picture within the frame, and then proceed to 'illuminate' the rest of the initial. The same procedure could be adopted with any letter of the alphabet, provided that it is bold enough. Initials of this sort should be used sparingly — just one at a time. They work well in conjunction with short statements or quotations written in a large size for wall display or as posters.

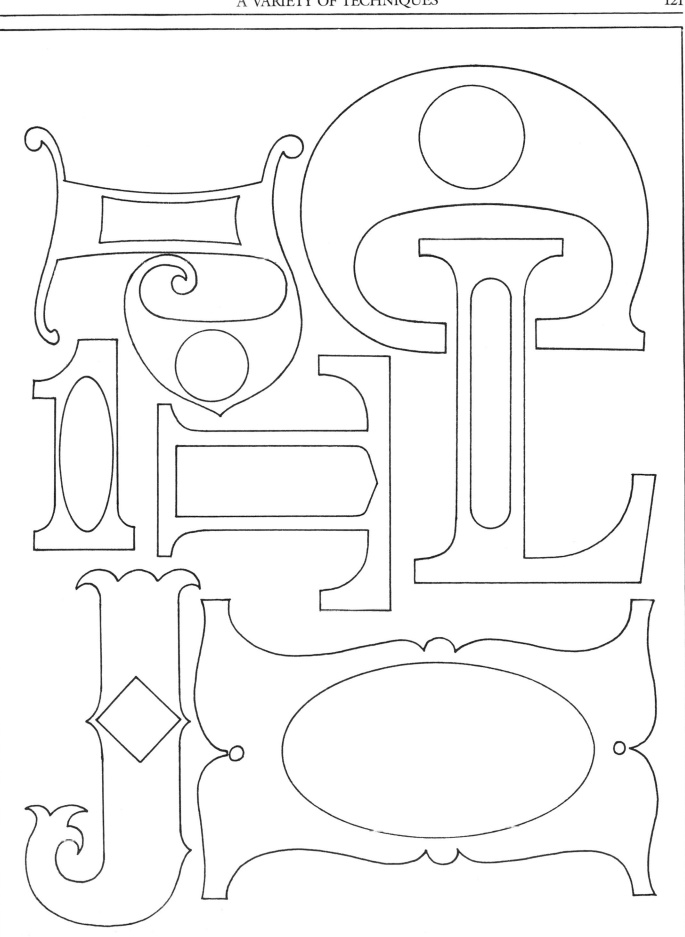

CHANGE OF ADDRESS CARDS

The first of the examples opposite is simply a formal announcement in a very basic hand with the lines centred within a restrained calligraphic border. The second is an informal message written in a fairly unassuming style mingled with a naïve sketch map of the locality — suitable for photo-copying and hand colouring (See also the coloured map and accompanying notes on page 00).

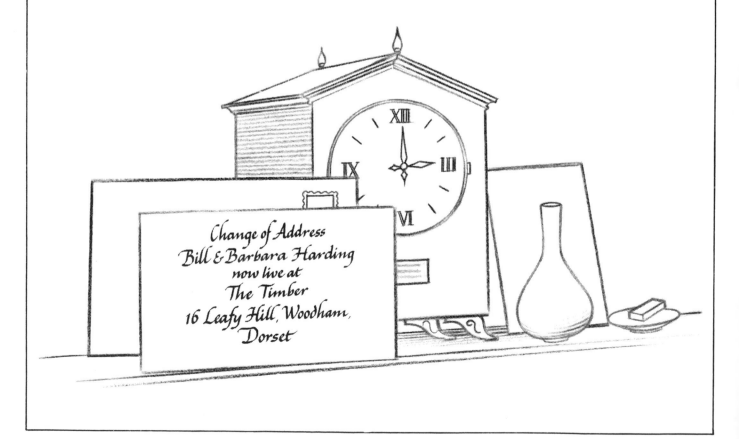

Change of Address
Bill & Barbara Harding
now live at
The Timber
16 Leafy Hill, Woodham,
Dorset

Robert and Sylvia Bellingham
will be moving on the 24th of March 1989
to their new home

Beavers Lodge
65 The Backwater
Briggs Norton. BT5 1GL
0741 16 5731

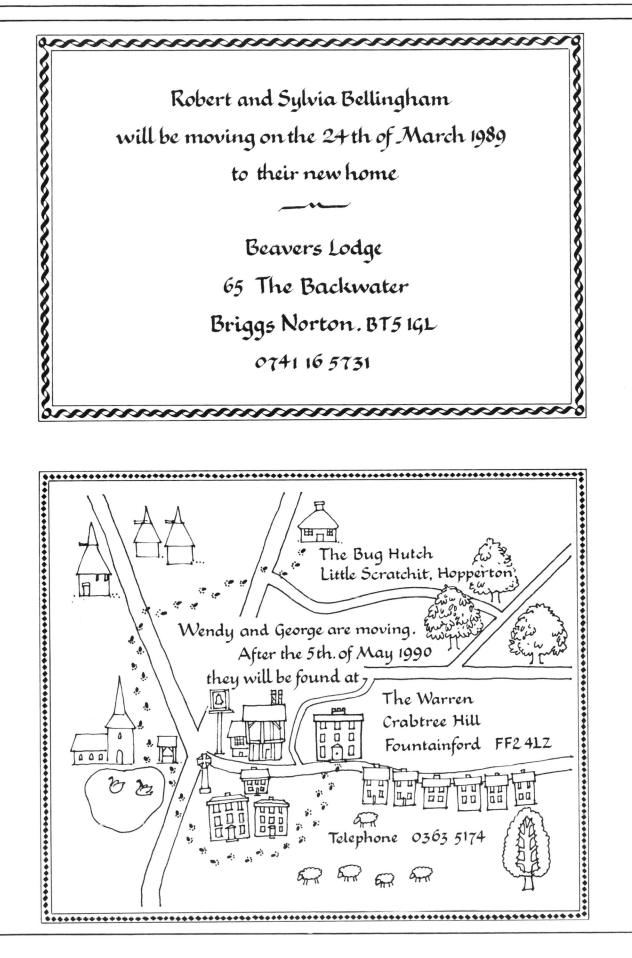

The Bug Hutch
Little Scratchit, Hopperton

Wendy and George are moving.
After the 5th. of May 1990
they will be found at

The Warren
Crabtree Hill
Fountainford FF2 4LZ

Telephone 0363 5174

HERALDRY

This diagram shows the main parts of a coat of arms or heraldic achievement. (See also the coloured version and accompanying notes.)

The seven heraldic colours are listed here with samples of the conventional hatching used to denote colours when represented in monochrome.

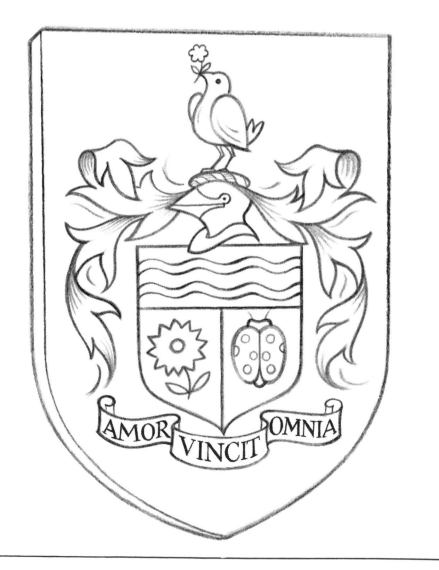

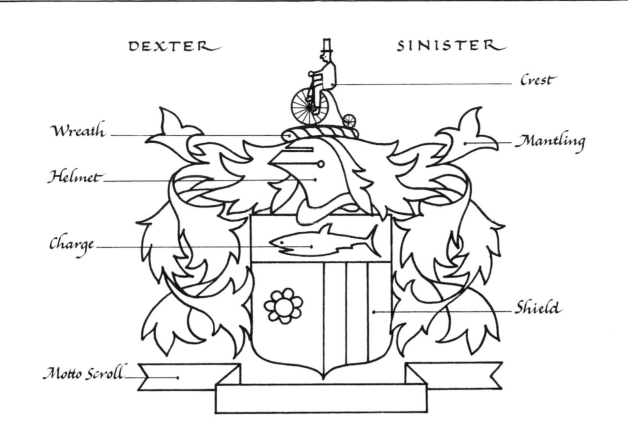

DEXTER SINISTER

Crest

Wreath

Mantling

Helmet

Charge

Shield

Motto Scroll

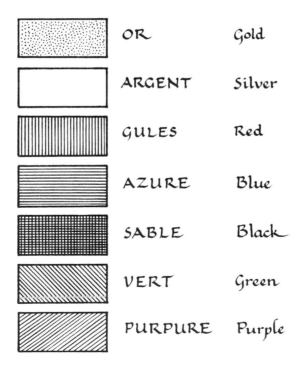

OR Gold

ARGENT Silver

GULES Red

AZURE Blue

SABLE Black

VERT Green

PURPURE Purple

LETTERING FOR SUGARCRAFT

None of these three examples was done with a chisel-shaped nib. All were drawn either with a technical pen or a marker. They could therefore be translated into cake icing. (See also the coloured sugarcraft design and accompanying notes.)

These designs could also be adapted for use as greetings cards.

The monogram is made from three Versal letters interwoven with each other. A useful approach is to draw the letters on separate pieces of tracing paper. These can then be manoeuvred into different positions until, with any luck, a satisfactory arrangement is achieved which can be transferred as one composite design.

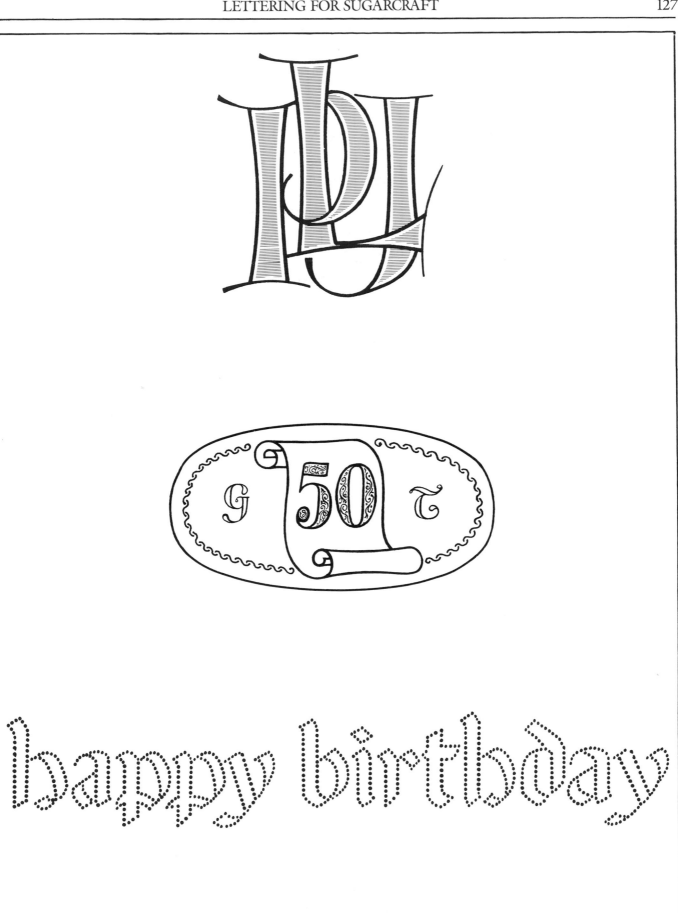

BOOK PLATE

Suitable for printing or copying on plain tacky labels, the design comprises three elements — the 'Ex Libris' device (pen lettered), the name in small capitals, and a monogram in Versals. There are several other permutations. Book plates also often have some pictorial or heraldic material.

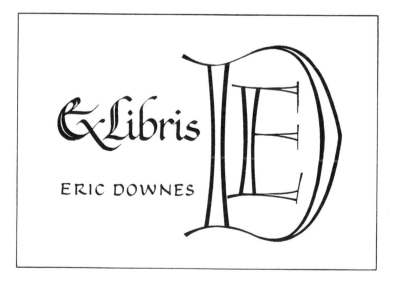